goicolea

Alter Ego: A Decade of Work by Anthony Goicolea

SCHOOL OF THE MUSEUM
OF FINE ARTS – BOSTON

Organized by the North Carolina Museum of Art, Raleigh, North Carolina,
and Telfair Museums, Savannah, Georgia, in collaboration with
21c Museum, Louisville, Kentucky

Exhibition Itinerary

North Carolina Museum of Art
Raleigh, North Carolina
April 17 - July 24, 2011

Telfair Museums: Jepson Center
Savannah, Georgia
September 2, 2011 - January 8, 2012

21c Museum
Louisville, Kentucky
January 27 - July 15, 2012

Organized by the North Carolina Museum of Art, Raleigh, North Carolina,
and Telfair Museums, Savannah, Georgia, in collaboration with 21c Museum,
Louisville, Kentucky.

Published by the North Carolina Museum of Art and Telfair Museums.

Front Cover Image: *Search Party* (detail), 2007, plate 29
Back Cover Images: (left to right) *For All the Days*, 2010 (plate 44); *Piñata*, 2010
(plate 45); *Siamese Twins*, 2010 (plate 46); *Umbrella*, 2007 (plate 30); *Fleeing*,
2005 (plate 22)

Designed by Stacy Claywell Edited by Kate Hoernle

Library of Congress Catalogue
Control Number: 2010940731
ISBN: 978-0-933075-15-3

Distributed by the University of Georgia Press
www.ugapress.org

Printed and bound in Canada by Friesens

Raleigh, North Carolina
www.ncartmuseum.org

Support is provided, in part, by the North
Carolina Department of Cultural Resources; the
North Carolina Museum of Art Foundation, Inc.;
and the William R. Kenan Jr. Endowment for
Educational Exhibitions.

Savannah, Georgia
www.telfair.org

General operating support for Telfair Museums
is provided, in part, by the Georgia Council
for the Arts through the appropriations of the
Georgia General Assembly. The Georgia Council
for the Arts also receives support from its partner,
the National Endowment for the Arts.

Alter Ego: A Decade of Work by Anthony Goicolea
at Telfair Museums is made possible through the
generous support of the Courtney Knight Gaines
Foundation.

Louisville, Kentucky
www.21cmuseum.org

21c Museum is a collecting institution
with a mission of exhibiting emerging
and internationally known living artists
working in all fields of contemporary art.

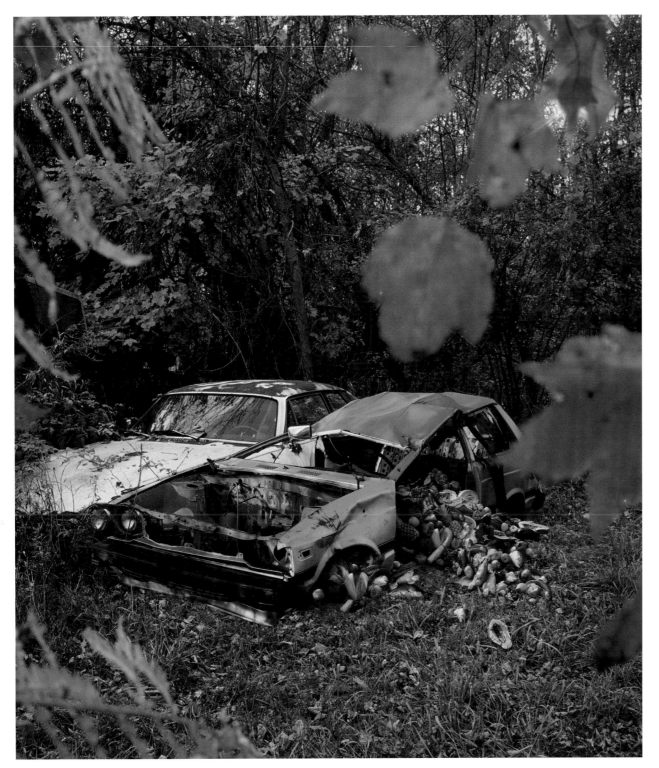

Plate 46
Siamese Twins (detail), 2010

Table of Contents

Directors' Introduction

Alter Ego: A Decade of Work by Anthony Goicolea, co-organized by the North Carolina Museum of Art and Telfair Museums, is the artist's first monographic exhibition to include both early and recent artworks that represent the vast scope of his career to date. Over the past decade, Anthony Goicolea has created a significant and highly successful body of work. This comprehensive exhibition features forty-nine works of art from the last ten years and includes loans from the artist and galleries, as well as works drawn from private collections and the permanent holdings of the North Carolina Museum of Art, Telfair Museums, and 21c Museum. *Alter Ego* is part of the organizing institutions' ongoing commitment to present solo exhibitions of artists with works in our permanent collections and to bring the global world of contemporary art to our visitors.

Goicolea's multimedia works depict an extraordinary world created by the artist. His photographs, drawings, paintings, videos, and installations focus on portraits and the landscape to explore issues of identity, family history, displacement, dislocation, environmental destruction, and globalization. The artist's ability to move with ease between traditional media, such as painting and drawing, to video and digitally manipulated photography has put him at the forefront of contemporary art.

It has been a pleasure to collaborate on all aspects of this exhibition and publication. We are thrilled that 21c Museum was able to participate in this project and gratefully appreciate the generous loans and assistance provided by Laura Lee Brown and Steve Wilson, and William Morrow, director of 21c Museum.

We would especially like to thank Anthony Goicolea for his vision, creativity, and collaborative spirit, which made working on this exhibition a fantastic experience for all involved. We are deeply grateful to the artist, the galleries, and the collectors for their willingness to lend their works to this exhibition. At Telfair Museums, we greatly appreciate the generous financial support provided by the Courtney Knight Gaines Foundation. At the North Carolina Museum of Art, we would like to thank our presenting sponsor, the North Carolina Museum of Art Contemporaries, and supporters Paul E. Coggins, Dr. W. Kent Davis, Dr. Carlos Garcia-Velez, R. Glen Medders, Michael Rubel and Kristin Rey, Hedy Fischer and Randy Shull, and Allen G. Thomas Jr.

The curators of the exhibition, Linda Johnson Dougherty and Holly Koons McCullough, are to be commended for their guidance of this ambitious show and publication. And, as always, our appreciation goes to the entire staffs of the North Carolina Museum of Art and Telfair Museums for the extraordinary professionalism and tremendous effort that ensured the success of this project.

Lawrence J. Wheeler
Director
North Carolina Museum of Art

Steven High
Director/CEO
Telfair Museums

Acknowledgments

This exhibition has been a truly collaborative process from the onset, and foremost, we would like to thank the artist, Anthony Goicolea, for his boundless creativity, his never-ending patience, his good-natured cooperation every step of the way, and for numerous exhilarating conversations which made this endeavor so successful and enjoyable from beginning to end. We want to express our gratitude to all of the lenders, whose enthusiastic support and willingness to loan important works made this exhibition possible at the North Carolina Museum of Art, Telfair Museums, and 21c Museum. We also want to thank the galleries and their staff members, who assisted us with numerous aspects of the show: Magda Sawon at Postmasters Gallery, New York; Aurel Scheibler at Aurel Scheibler Gallery, Berlin; and Jade Awdry and Emily Cullen at Haunch of Venison Gallery, London. We have thoroughly enjoyed working with our partner and colleague William Morrow, director at 21c Museum, as well.

Coordinating and presenting this exhibition and catalogue called on the expertise of every department at both of the organizing museums. At the North Carolina Museum of Art, Tiara L. Paris, exhibitions manager, kept us all on track and on schedule, organizing and staying on top of a myriad of details and complications with her usual calm and collected demeanor. Curatorial assistant Jennifer Dasal provided invaluable assistance, handling every task with grace, competence, and good humor. Interns Laura Curtis and Lindsay Gordon eagerly devoted countless hours to this project and performed valuable background research. Special thanks also go to North Carolina Museum of Art staff members who were instrumental in determining the success of this exhibition and publication: Caterri Woodrum, chief deputy director; John Coffey, director for art; Maggie Gregory, chief registrar; Angie Bell-Morris, associate registrar; Tom Lopez, head art handler; Karen Malinofski, head photographer; Conservation department; Eric Gaard, head of exhibition design; Virginia Patterson, exhibition designer; Barbara Wiedemann, head of graphic design; Dave Rainey, graphic designer; Karen Kelly, senior editor; Sonya Robinson, grant and foundation relations; and Genevieve Joseph, development officer.

At Telfair Museums, associate curator Courtney McNeil demonstrated her characteristic poise, efficiency, and formidable organizational skills, assisting with the coordination of this exhibition from its inception. Ever-dependable registrar Jessica Mumford provided critical assistance with the budget and cheerful oversight of the complexities associated with multiple loans and varied shipping and installation requirements. Assistant curator Beth Moore supplied crucial assistance with the comparative images in this book, as well as label copy for the exhibition. Preparators/designers Milutin Pavlovic and Heath Ritch formulated an initial installation plan and effected a beautiful presentation in the galleries of the Jepson Center. Kate Hoernle, publications editor, rescued us with her outstanding eye for textual inconsistencies, and her articulate and much-appreciated revisions to this book. Stacy Claywell deserves ample credit for the striking design of this catalogue and her enthusiastic participation in this project. Marketing and public relations director Kristin Boylston patiently and capably oversaw the catalogue's design and production process.

We would also like to express our gratitude to our directors, Lawrence J. Wheeler at the North Carolina Museum of Art and Steven High at Telfair Museums, for their unwavering enthusiasm and support of this project.

Linda Johnson Dougherty
Chief Curator and Curator of
Contemporary Art
North Carolina Museum of Art

Holly Koons McCullough
Director of Collections and Exhibitions
Telfair Museums

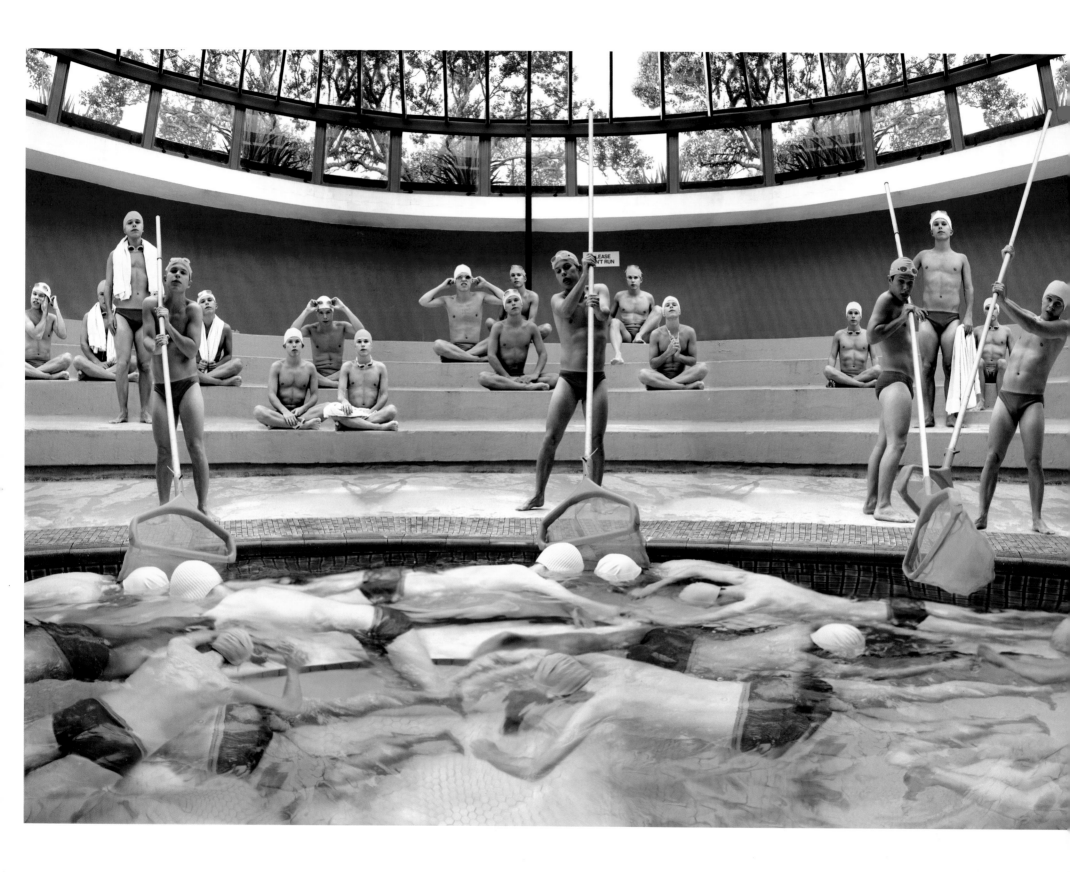

Plate 6
Pool Pushers, 2001

Linda Johnson Dougherty

Shape Shifter:
Portraiture and Identity in Anthony Goicolea's Work

Over the past decade, Anthony Goicolea has continually shifted back and forth between portraiture and the landscape in his multimedia works. Drawing upon current events, art history, religion, myths, fairy tales, science fiction, and dreams, he creates complex works that are simultaneously enigmatic, seductive, ambiguous, humorous, unsettling, and provocative. His earlier images focused on adolescent rites of passage and teenage male protagonists—some in black-and-white, but most set in decadent, almost baroque, environments saturated in color, and playing off of childhood memories and fantasies. These works were followed by a series of imaginary and artificially hued, hyper-real landscapes. He then turned to a more somber and contemplative monochromatic palette in large-format photographs that melded contemporary issues of environmental destruction and globalization with film noir and nineteenth-century landscape painting. This was followed by a series that explored issues of displacement, dislocation, and aging, with portraits and installations that focused on his extended family. In his most recent body of work, *DecemberMay*, 2010, Goicolea continues to alternate between the portrait and the landscape with a series of images of abandoned places and portraits of young children.

Goicolea's overtly manipulated photographs present mysterious scenes that are open to numerous interpretations. He is the consummate storyteller, providing just enough information to set the scene and then leaving it up to the viewer to fill in the story line. Like a theatrical stage set, his photographs and videos depict a fantastic world completely fabricated by the artist. He draws from a vast archive of imagery, a huge data bank of photographs from all of the places he has visited, to create elaborate digital compositions that collage and meld disparate images. His manipulated photographs are technical tours de force, so seamless and flawless that it is impossible to discern fiction from reality. None of the places or crowds of people depicted in his images actually exist—single trees are photographed in different sites and then combined to make a forest, individual faces are photographed and then multiplied by the artist.

Goicolea's early work focused on multiple self-portraits to explore issues of identity, sexuality, childhood, adolescence, and the transition to adulthood. Up until 2002, Goicolea—disguised by costumes, wigs, and makeup—used digital manipulation to "clone" himself to play the starring role in all of his images. *Class Picture,* 1999 (plate 1), consists of twelve boys dressed in school uniforms sitting in rows on the steps of an ivy-covered building—a seemingly normal prep school class picture until one realizes that all of the boys have the exact same face, the artist's. In *Fraternal,* 2000 (fig. 1), two boys sit on a couch, one blond, one brunette, wearing school blazers and ties; they are Siamese twins who share one leg and the same face, bringing to mind fertility drugs or cloning gone haywire.

The series created during this time, including *You and What Army,* 1999, *Detention,* 2001, and *Underwater,* 2001-02, present a boys' world of eternal childhood, perpetual adolescence. Comprising a tribe of lost boys who will never grow up, they are frozen in time at summer camp, Boy Scouts, sleepovers, and prep school. The images are painfully awkward, self-conscious, and often humorous. In these early works, the artist's surrogate selves are depicted acting out a drama filled with power struggles, survival of the fittest, and implications that boys can easily become barbaric savages when left to their own devices, with images that readily call to mind scenes from William Golding's 1954 novel, *Lord of the Flies.*

As Goicolea has stated in reference to the series *You and What Army* (which includes *Class Picture* and *Fraternal*), "Through digital manipulation, I am able to clone myself and create scenarios in which I act out childhood incidents such as fight scenes, first kisses, and deranged play dates. These works are simultaneously rooted in nostalgia and science fiction. Many of the sets are constructed to depict suburban environments in which the cast of characters are seen undertaking painfully awkward transformations as they undergo the journey from childhood to adulthood and the hazy boundaries in between."[1]

Even though most of the works in the *Detention* series have a dark undercurrent, Goicolea's idiosyncratic sense of humor continues to surface, as in *Window Washers,* 2001 (fig. 2), which shows a boy licking the condensation off of a long window. In *Blizzard,* 2001 (plate 4), the picture is split between a group of boys fleeing the scene by climbing up a chain-link fence, while a nearby boy hoards potatoes, and another has been caught by the only adult in sight—

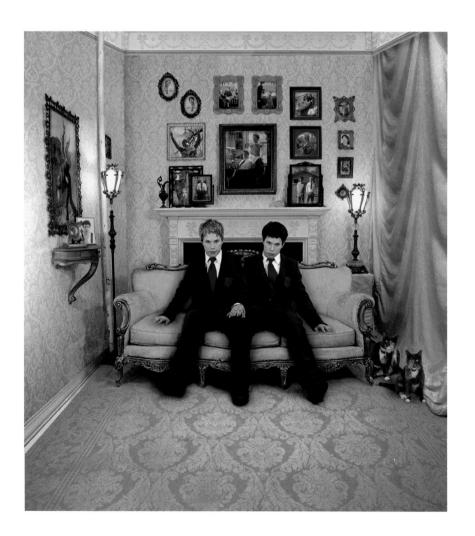

Fig. 1
Anthony Goicolea, **Fraternal**, 2000, chromogenic print, 45 x 40 inches
Courtesy of the Artist and Postmasters Gallery, New York

Plate 3
Warriors, 2001

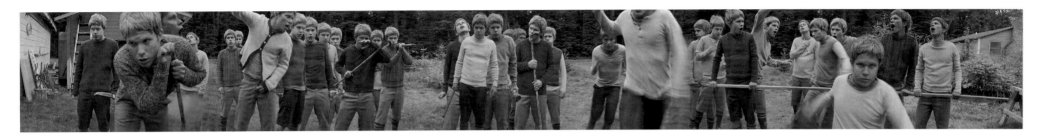

a man with an obscured face and an ominous presence. *Warriors,* 2001 (plate 3), depicts an army of boys with menacing expressions and a variety of weapons, including sticks, spears, and knives; all with Goicolea's face, they are an army of one on the verge of battle or playground warfare. In reference to the *Detention* series, Goicolea has stated, "[these works] seem to derive their inspiration from the harsh realities of childhood existence in institutional and repressive environments which are often paralleled with references to periods of war, pestilence and famine. Where the earlier photographs often pitted child against child in either literal or metaphoric terms, here the kids seem to be fighting both the elements and a generalized outside threat."[2]

Goicolea has described the *Underwater* series, including *Amphibians* (plates 11a and 11b) and *Pool Pushers* (plate 6), as addressing "issues of age and gender, self-love and self-hate, discipline and impulse, technology, religion and science, all within a framework of homogeneity and mass production."[3] These works slide back and forth between a sense of foreboding and danger, along with harmless childhood play. He presents a slippery world filled with uncertainty, in which it is hard to find one's bearing; it is simultaneously

absurd and threatening. In *Pool Pushers,* 2001, a number of identical boys in blue bathing suits sit in rows on the bleachers, watching their clones use poles to push their surrogate selves around in the pool. In the artist's words, "Above the water level the onlookers sit in a scene of perfect order and discipline, while below exists a world of confusion, playfulness, and impending doom."[4]

In the six-minute video *Amphibians,* 2002, boys dressed in hooded red capes, a multiple male version of Little Red Riding Hood, run through a forest, progressively multiplying in number. The only sounds are those of their footsteps hitting the path and the ambient forest noises of birds and insects. They emerge from the forest at the edge of a lake and run directly into the water, shedding their clothing. In contrast to the panicked, fearful undercurrent that accompanies the scenes in the forest, the mood is considerably lighter once they reach the water. Undergoing a reverse evolution from land to water, the boys seem completely free, as if they have returned to their real home.

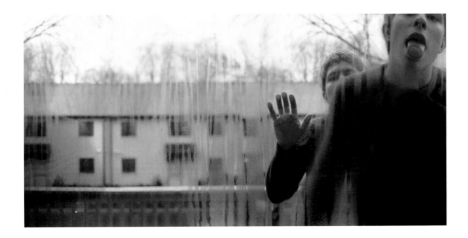

Fig. 2
Anthony Goicolea, **Window Washers**, 2001
chromogenic print, 40 x 82 inches
Courtesy of the Artist and Postmasters Gallery, New York

In 2004-05, with series including *Kidnap* and *Sheltered Life,* Goicolea began directing other people to play the parts (although he would occasionally appear, as he does in the *Kidnap* video) in his highly staged photographs and videos. He remained inextricably involved with every detail that led up to the finished work of art—building the set, designing the wardrobe, doing the makeup, taking the photographs, and digitally composing the final image (which alone could take over a month to complete).

Kidnap includes an architectural installation, a video, and several photographs. Goicolea describes the theme of the series as "the tale of a young boy's obsession and paranoia of being kidnapped. Shot in the countryside outside of Basel, Switzerland, several characters dressed in red-hooded uniforms engage in a series of clandestine rituals that unfold in a fairytale-like sequence."[5] The fifteen-minute video *Kidnap,* 2004-05, (plate 19), tells a story that constantly moves between past and present during a twelve-hour period from dusk to dawn. The characters are played by a gang of teenage boys in red-hooded sweatshirts. A huge bonfire, built by the boys, appears as the constant backdrop throughout the series in its various states from construction to incineration to ashes. The video is narrated via subtitles by a protagonist who

"reflects back on his childhood terror of falling asleep, fear of the dark and a recurring fantasy in which he is kidnapped and cloned."[6] The photographs, such as *Midnight Kiss,* (plate 14), and *Morning Sleep,* 2004 (plate 15), convey a parallel story line but depict scenes not included in the video: a secret kiss, a group of boys sprawled across a frost-covered field and sleeping around the smoking coals of the bonfire.

Sheltered Life spins a complicated narrative of boys on the run and living in an imaginary world on the outskirts of society. In the large-scale photograph *Still Life with Pig,* 2005 (plate 20) two boys sleep in a flimsy shelter of cardboard boxes and tree limbs. The boys huddle together, their faces blackened with dirt or face paint, and the remnants of an extravagant feast spill out across the ground in front of them. A whole pig with an apple in its mouth, mounds of fruit and vegetables—this vividly hued still life looks as if it were lifted from a seventeenth-century Baroque painting.

Goicolea has described the *Sheltered Life* series as depicting "fairytale-like, timeless places inhabited by contemporary characters. ...Many of the figures in the photos are reduced in size and are almost swallowed by their surroundings. The characters are often masked, hooded, or seen from the back in order

Plate 20
Still Life with Pig, 2005

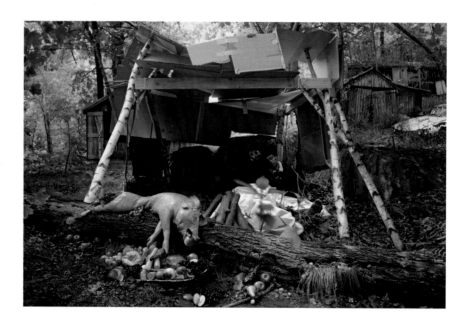

Fig. 3
Justine Kurland, **Boy Torture: Double Headed Spit Monster,** 1999
Satin laminated chromogenic print, 30 × 40 inches
Courtesy of Mitchell-Innes and Nash Gallery, New York

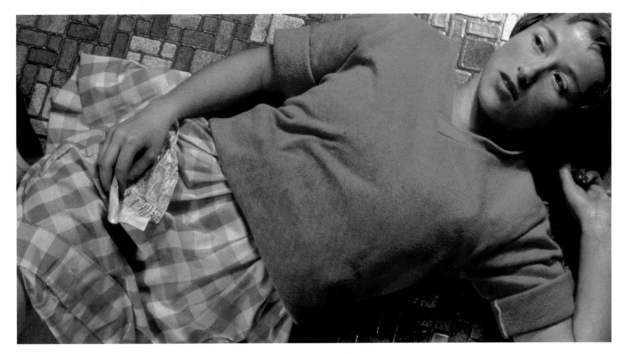

Fig. 4
Cindy Sherman, **Untitled #96,** 1981
Color photograph, 24 x 48 inches
Courtesy of the Artist and Metro Pictures, New York

to preserve their identity. They operate as a single unit, living in situations that simultaneously reference backyard play dates and hippie communes, as well as detainment camps and disaster relief areas. Their living arrangements and concealed identities cement their status as outcasts or refugees from society. ...The shelters that inhabit the photos range in form from tree houses, lean-tos and caves, to cardboard forts or dilapidated barns. Their playfulness undermines the sort of desperate haphazard construction and deeper desire to migrate or live on the outside of communities."[7]

In *Tree Dwellers,* 2004 (plate 17) a group of boys in ski masks, dressed in red sweatshirts or prep school shirts and ties, surrounds an enormous tree filled with an assortment of ramshackle tree houses, a fantastic outpost for feral children. The boys in *Sheltered Life* are rowdy, rambunctious, and wild. They are captured acting out bizarre and enigmatic rituals in anonymous packs or gangs, as if they have given up their individual identities to be part of the group—finding safety in numbers.

As one writer has aptly described Goicolea's work at this time, "Goicolea's deft synthesis of hauntingly beautiful, often malevolent interior worlds remains both recognizable and yet utterly uncanny. Drawing upon familiar narratives and characters of male youth, both impotent and violent, raging in adolescent flux, he taps into the darker, ambiguous underbelly of contemporary life via these specific and metaphorical instances of intense, often ritualistic, emotional experience. In the contemporary world, we have been led both to fear and

to desire the state of youth—a conflict that Goicolea mines repeatedly to varying effect. He explores the ongoing anxieties and failures of memory, desire, violence, and will—not as an end in itself, but as a means to understand a world seemingly devoid of the recognition of its own complexity."[8]

Goicolea's constant re-invention of himself—his early focus on self-portraiture, and its inherent vanity and narcissism—is inescapably linked to and influenced by Cindy Sherman's self-portrait photographs from the 1970s and 1980s (fig. 4). Employing wigs, costumes, fake body parts, and theatrical makeup, Sherman transformed herself into movie stars, historical figures, centerfolds, and fantasy characters. Her multiple and shifting identities played with the idea of the photograph as a created fiction, an artificial construction, instead of a document of truth or reality.

As Jennifer Dalton stated in her insightful article *Look At Me: Self-Portrait Photography After Cindy Sherman,* "Any photographer working with self-portraiture today is necessarily working in the long shadow cast by Cindy Sherman."[9] Dalton's article includes Goicolea along with Nikki Lee, a contemporary Korean American artist who, like Goicolea, creates chameleon-like self-portraits in which she turns herself into members of wildly different subcultures and social and ethnic groups (yuppies, Japanese schoolgirls, skateboarders, Hispanic teenagers, drag queens, strippers, motorcycle gangs) by reconstructing and radically transforming her identity with makeup and costumes in the manner of Cindy Sherman.

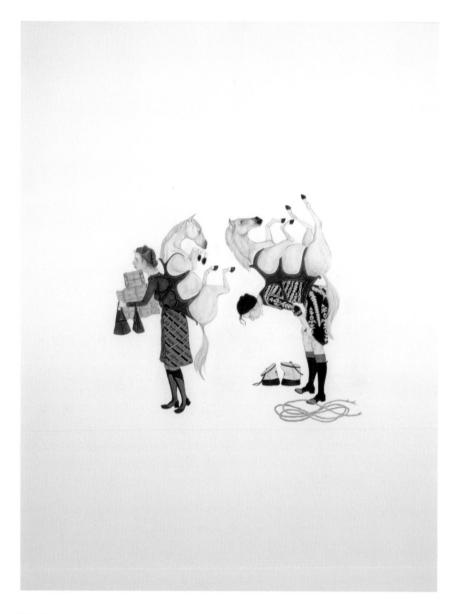

Goicolea's imagery also aligns with works by other contemporary artists, including Anna Gaskell's elaborately staged photographs exploring the transition and transformation of girls to women in Alice in Wonderland-like scenes and Justine Kurland's photographs of roaming packs of runaway teenage girls (fig. 3). As Dalton notes in her article, "The creepy/innocent dialectic of childhood has been mined furiously in recent years, notably in the photographs of girl-chroniclers like Anna Gaskell and Justine Kurland," but primarily by women artists focusing on girls.[10] Goicolea's boy-centric world is less prevalent in the work of his peers, and as Dalton goes on to say, "The adolescent sexuality of females has been much more accessible territory than that of males, perhaps because the innocence, naiveté, frailty, (and by extension, the potential corruptibility) of girls is such an immensely popular theme in our culture...."[11]

One can also find parallels between Goicolea's fantastic, fairytale-like imagery and Amy Cutler's intricately detailed drawings and paintings. In Cutler's all-girl world, dreamlike narratives and imaginary scenes unfold across the paper, illustrating an eccentric feminine version of the Brothers Grimm. In *Tiger Mending,* 2003, a group of women "mends" tigers at an outdoor sewing bee; in *Saddlebacked,* 2002 (fig. 5), two women carry horses on their backs like backpacks. Although Goicolea and his contemporaries, including Cutler, Kurland, Gaskell, and Lee, seem to be tapping into a common thread in their work, Goicolea has forged his own way and created his own distinctive path with his focus on adolescent boys.

Fig. 5
Amy Cutler, **Saddlebacked,** 2002, gouache on paper, 30 x 22 3/4 inches
Weatherspoon Art Museum, University of North Carolina at Greensboro,
Museum purchase with funds from the Dillard Fund for the Dillard Collection, 2002

Fig. 6
Henry Darger (1892-1973), **Chicago, At 5 Norma Catherine. But Are Retaken,** c. 1950-70
Watercolor, pencil carbon tracing, and collage on pierced paper, 23 x 36 3/4 inches
Collection of the American Folk Art Museum, New York, Gift of Sam and Betsy Farber,
© Kiyoko Lerner, 2003.8.1, Photographed by Gavin Ashworth, New York

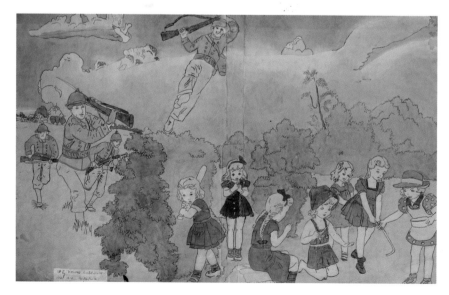

There is also a fascinating connection between Goicolea's works and those of the self-taught/outsider artist Henry Darger (1892-1973), who created hundreds of paintings illustrating the surreal fairytale world of the "Vivian Girls" (fig. 6). A tribe of hybrid girl-boy characters, the Vivian Girls are depicted by Darger as having numerous fantastic adventures filled with constant struggles between good and evil. In a recent exhibition, *Dargerism,* that paired Darger with contemporary artists, including Goicolea, the curator noted that "Anthony Goicolea had already been exploring childhood and fairy tales in his photography and videos when he discovered Henry Darger. The self-taught artist's influence appeared in Goicolea's work shortly thereafter, when Goicolea began to incorporate Darger's artistic methods (he even traced his drawings into his own artwork) and aesthetic judgments into his photographs, drawings, and paintings. ...both artists share a penchant for creating myths and provoking an audience into discomfort. Both artists create unsettling images through collage technique (low-tech with scissors and paste in Darger's case, high-tech with Photoshop in Goicolea's), building highly charged surreal narratives that are layered with alarm and humor. Darger and Goicolea share a prepubescent energy that pops off the wall when these works are paired."[12]

In Goicolea's words, "My first exposure to Henry Darger was at the American Folk Art Museum. I accidentally stumbled across it. ...I remember being struck by the fact that we both worked in long, cinematic, horizontal formats and we were working toward creating character-based mythologies. Hand-tracing duplicate images of schoolgirls, Darger used analog techniques to multiply his characters and create groups of seemingly identical figures working and fighting toward a common goal. Similarly, I was using modern technology to digitally duplicate my own image and create an army of identical boys playing out issues of group politics and identity."[13]

Goicolea is a master draftsman, and his layered works on Mylar and Plexiglas incorporate collage (often including disparate materials like straw, glitter, poppy seeds, horseflies, and/or gold leaf) and acrylic paint into intricately detailed ink and graphite drawings—expanding on the narratives found in his photographs and videos to create surreal, dreamlike images. In *Fleeing,* 2005 (plate 22), (which was included in the *Dargerism* exhibition) a crowd of children is on the run, with the older ones carrying the younger ones. They move through a Hansel and Gretel-like enchanted forest, a tangled web of black trees with real horseflies collaged onto the image surface. In *Cat's Cradle,* 2004 (plate 16), a group of children is playing a familiar game where two people weave string back and forth between their hands to form different shapes. But in this creepy, science-fiction scenario, the other ends of the strings are tied to giant transmission towers—a playground for wayward children? In *Search Party,* 2007 (plate 29), masked men in a hot air balloon aim their flashlights below as they float over a city covered in a web of power lines, crisscrossing between telephone poles and transmission towers.

Plate 16
Cat's Cradle, 2004

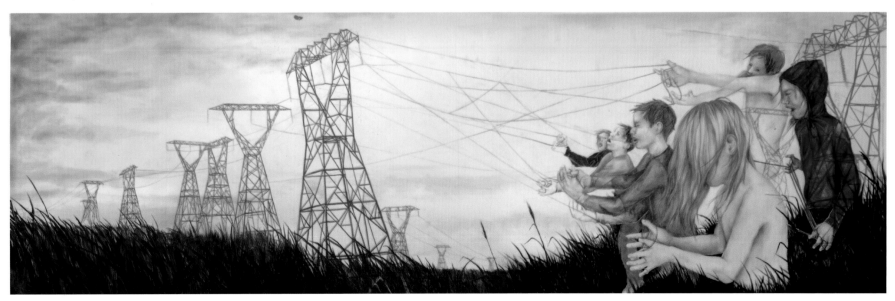

Plate 22
Fleeing, 2005

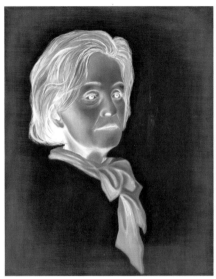
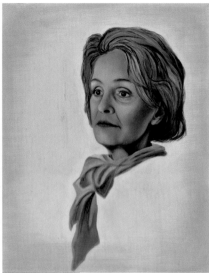

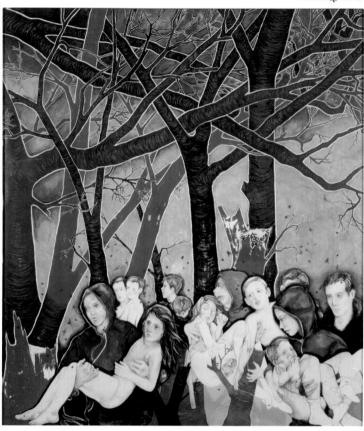

Fig. 7
Anthony Goicolea, **Anita,** 2007
Diptych: acrylic, graphite, and ink on Mylar (left) and chromogenic print (right);
17 x 14 inches ea.
Courtesy of the Artist and Postmasters Gallery, New York

In 2007, Goicolea created a new series, *Almost Safe,* of black-and-white land-scapes that combined photographs from all over the world (Paris, Greenland, upstate New York, Vancouver, and other places) to create surreal images. Usually uninhabited, these desolate landscapes suggested a human presence primarily by its absence. *Almost Safe* was shown with a series of ten diptych portraits of elderly men and women that resembled nineteenth-century da-guerreotypes, such as *Anita,* 2007 (fig. 7). The works combined positive and negative images—one, a transparent drawing on Mylar (a drawing of a pho-tograph), and the other, a sepia-toned chromogenic print (a photograph of a drawing). These diptychs led directly to his next series of family portraits.

In Goicolea's two major bodies of work from 2008, *Related,* and 2009, *Once Removed,* he focuses on genealogy and family history, exploring the past and his extended family as a way to construct and understand his own identity as a first-generation Cuban American. His extended family emigrated from Cuba to the United States in 1961, soon after Castro came to power. They fled the country with just a few belongings, including family photographs, and never returned. Goicolea went to Havana for the first time in May of 2008 and visited the places his family members left behind, using their drawn-from-memory maps to find the homes, farms, schools, and churches from their past.

In reference to this body of work, Goicolea has said, "I've always had these different stories from different relatives about what it was like growing up in Cuba, how they'd left, how they came [to America] and what it's like now. So it's become this mythic place in my head and I think that's something a lot of first-generation immigrants experience. They grow up with certain customs and stories indicative of their homeland. They have this connection to a place they've never really experienced, but they also have the place they actually grew up in. Having those two things and not feeling fully connected to either leaves this sensation of alienation."

"The initial starting point for this series *[Related]* was dealing with my family history, and the fictions that are built into family histories. Since my family is from a place that I can't really go back to for political reasons, there is this whole mythology woven into it. So I was interested in exploring that, and doing it in a way that has a sense of nostalgia because that's the way I've experienced it. As a child it was only through story-telling and photographs [that I connected with it]. I always think it is interesting to be nostalgic for a period that you didn't actually live through."[14]

Goicolea used old photographs of family members who had lived or remained in Cuba—his parents, aunts, uncles, cousins, grandparents, and great-grand-

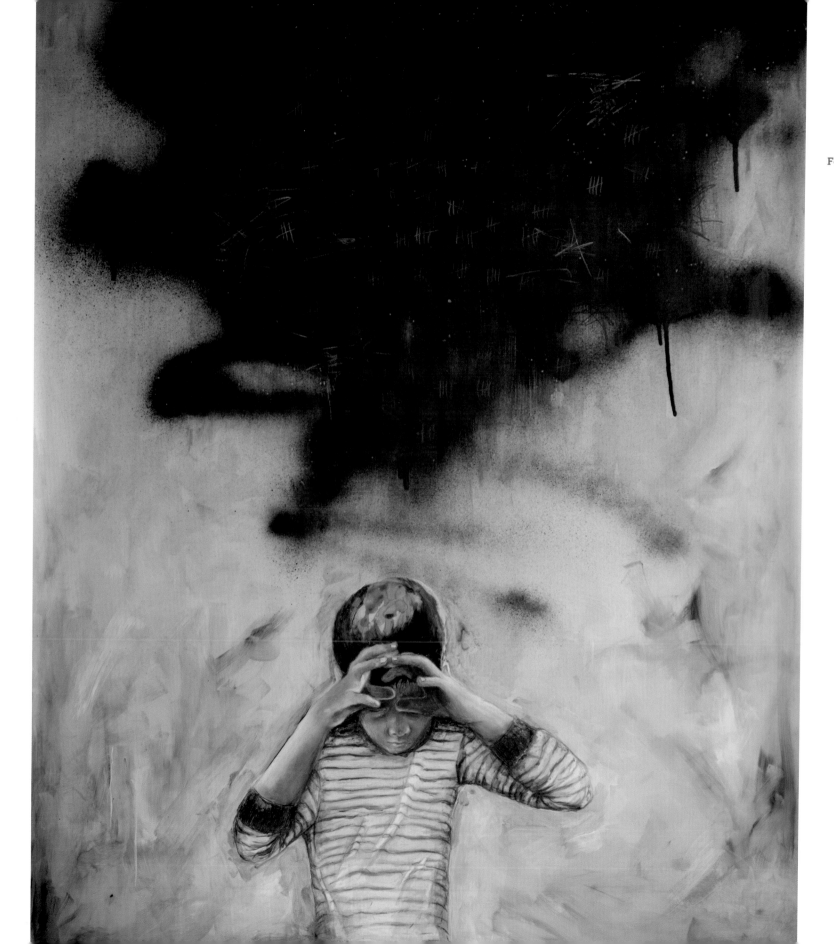

Plate 44
For All the Days, 2010

Plate 41
Family Geometry, 2008

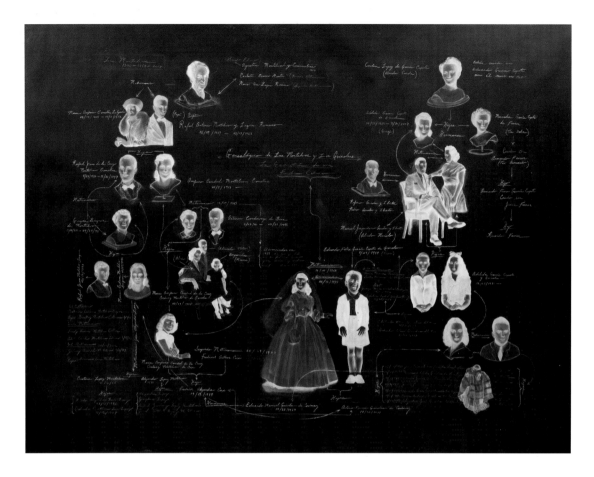

parents—as the starting points for these portraits. Bearing a historical patina, the images in these series resemble antique daguerreotypes, old photographs from family albums, and lockets. The artist combined drawing, painting, and photography to produce a series of negative and positive images. Using the family portraits as source material, he created hand-drawn negative images, from which he generated positive, mirror-image photographs. He then took the paintings and photographs of the first-generation drawings outside and mounted them on trees, telephone poles, and the sides of buildings and photographed them in situ—as can be seen in *Related 1a* and *1b,* 2008 (plates 36 and 37) —in locations where he had lived and grown up, as well as where he currently resided. In the artist's words, "By drawing or painting the portraits of unfamiliar or unknown family members, I am creating a reinterpreted, second-generation reproduction of their likeness. …In their newly contextualized environments, the portraits take on the appearance of missing persons ads or wanted posters while memorializing past relatives that have had an indirect effect on my life."[15]

Reconstructing history, memory, and the past, Goicolea creates a fictionalized family history, as exemplified in *Family Geometry,* 2008 (plate 41), a painting of an elaborate family tree filled with incandescent, glowing portraits. Fabricating family events that never happened, he depicts dinners and reunions peopled by ghosts. These haunting images—such as the positive/negative diptych *Related 26a and 26b,* 2008 (plate 40), which presents a multi-genera-

tional family portrait at the base of an elaborate staircase—call into question the original versus the reproduction, with his copies of copies, each one further removed and dislocated from the original image.

In *Night Sitting,* 2009 (plate 42), Goicolea composes a portrait that includes four generations from both sides of his family. Gathered on the family farm in Cuba and surrounded by twinkling strands of party lights, as well as film equipment and stage lights, they are like actors assembled for a play or movie. In Goicolea's words, "The family members are rendered in their most idealized states from when they were living in Cuba."[16] For instance, he depicts his great-grandmother as the same age as his aunt and his mother. Romantic, nostalgic, poignant— these formal, posed portraits capture everyone in an ideal, utopian moment. All of these images have a glamorous aura, recalling a retro Hollywood era.

Referencing the sea wall that surrounds the Havana harbor, *Sea Wall,* 2008 (plate 39), consists of a series of twenty-four hand-blown glass bottles that sit on top of a cast glass-block wall, a translucent version of a cinder-block wall. Each bottle is filled with a scrolled portrait, one of the artist's relatives, drawn on a sheet of Mylar and sealed in the bottle. *Sea Wall* evokes numerous associations, perhaps most pointedly, the idea of a "message in a bottle," tossed into the ocean and washing up anywhere around the world, just like refugees fleeing Cuba in boats and washing ashore somewhere.

In describing the bottles, Goicolea has said, "They do relate to that iconic imagery, and to refugee immigrants wanting to escape and sending out messages, but for me it was more about placing something out of reach, because the bottles are completely sealed. There are these delicate, seductive drawings inside them that you want to look at, but they're slightly obscured so it's impossible to get to them." [17]

In reference to the *Related* series, he has said, "Even though this work is very personal to me, there's a universal aspect to it, a level of alienation and dislocation that comes from growing up in a different environment than your family and relatives did. I think that in an age where so many people are emigrating from one country to another there's this feeling of loss and alienation, of not knowing quite how you fit in. I always like to work in a realm of ambiguity that operates in a very specific way, but also more generally so things can be read differently, depending on who's viewing it." [18]

In Goicolea's most recent work, the series *DecemberMay*, 2010, the figure is once again mostly absent, but a human presence is suggested nonetheless by its aftermath with images that present the evidence of hoarders, scavengers, characters hiding out or on the run. In these photographs, inanimate objects take on anthropomorphic qualities, like *Siamese Twins*, 2010 (plate 46), in which two junked and abandoned cars sit companionably side by side, and a lush cornucopia of fruit, vegetables, and fish spills out of the car doors. Some of these recent works include portraits of young children, as in *For All the Days*,

2010 (plate 44), a painting of a small boy with his hands over his eyes and a black cloud floating over his head that is filled with hatch marks used to count down the days. Although many of the works in *DecemberMay* resonate with loneliness and isolation, sometimes even desperation, Goicolea describes the inclusion of images of children as bringing with them "a sense of renewal and hope for the future." [19]

Throughout his career, Anthony Goicolea has returned repeatedly to the portrait to examine issues of identity—age, gender, sexuality, ethnicity, heritage, family, and relationships. Constantly re-inventing himself, as well as his surroundings, Goicolea explores how one portrays oneself and others, and how those constructions can shape or interpret one's identity. His elaborately crafted images are nostalgic, narcissistic, darkly humorous, and often provocative—upending the viewer's expectations. A shape shifter, an escape artist, a storyteller, Goicolea creates visually seductive hybrid portraits filled with saturated colors, imaginary settings, and atmospherically dreamy environments. His is a fantastic world that examines the essence of human experience and what it means to be an individual in a complicated and constantly shifting reality.

Linda Johnson Dougherty
Chief Curator and Curator of Contemporary Art
North Carolina Museum of Art

1 Anthony Goicolea, "*You and What Army* Series Statement," accessed October 2010, http://www.anthonygoicolea.com/NewAnthonySite/pages/youandwhatstatement.html.

2 Anthony Goicolea, "*Detention* Series Statement," accessed October 2010, http://www.anthonygoicolea.com/NewAnthonySite/pages/detentionstatement.html.

3 Anthony Goicolea, "*Water* Series Statement," accessed October 2010, http://www.anthonygoicolea.com/NewAnthonySite/pages/waterstatement.html.

4 Ibid.

5 Anthony Goicolea, "*Kidnap*," accessed October 2010, http://www.anthonygoicolea.com/NewAnthonySite/pages/kidnapstatement.html.

6 Ibid.

7 Anthony Goicolea, "*Sheltered Life* Statement," accessed October 2010, http://www.anthonygoicolea.com/NewAnthonySite/pages/shelteredstatement.html.

8 Shamim M. Momin, "Anthony Goicolea," in *Vitamin Ph: New Perspectives in Photography* (London: Phaidon Press Inc., 2006), 104.

9 Jennifer Dalton, "*Look At Me: Self-Portrait Photography After Cindy Sherman*," PAJ: A Journal of Performance and Art, Vol. 22, No. 3 (Sep., 2000) Published by The MIT Press on behalf of the Performing Arts Journal, Inc., 47.

10 Dalton, 50.

11 Ibid.

12 Brooke David Anderson, *Dargerism: Contemporary Artists and Henry Darger* (New York: American Folk Art Museum, 2008), 21. This exhibition and catalogue explored Darger's influence on contemporary artists, including Cutler, Kurland, and Goicolea.

13 Goicolea, quoted in *Dargerism*, 21.

14 Goicolea, quoted in "Anthony Goicolea: Goicolea visits Havana," *Haunch* (London: Haunch of Venison, 2008), 10.

15 Anthony Goicolea, artist's statement for ARCO 2008 project, February 15, 2008.

16 Anthony Goicolea, "*Once Removed* Statement," accessed October 2010, http://www.anthonygoicolea.com/NewAnthonySite/once_removed/once_removed_statement.html.

17 Goicolea, quoted in "Anthony Goicolea: Goicolea visits Havana," *Haunch* (London: Haunch of Venison, 2008), 10.

18 Ibid.

19 Anthony Goicolea, "*DecemberMay* Statement," accessed October 2010, http://www.anthonygoicolea.com/NewAnthonySite/dec_may/december_may_statement.html.

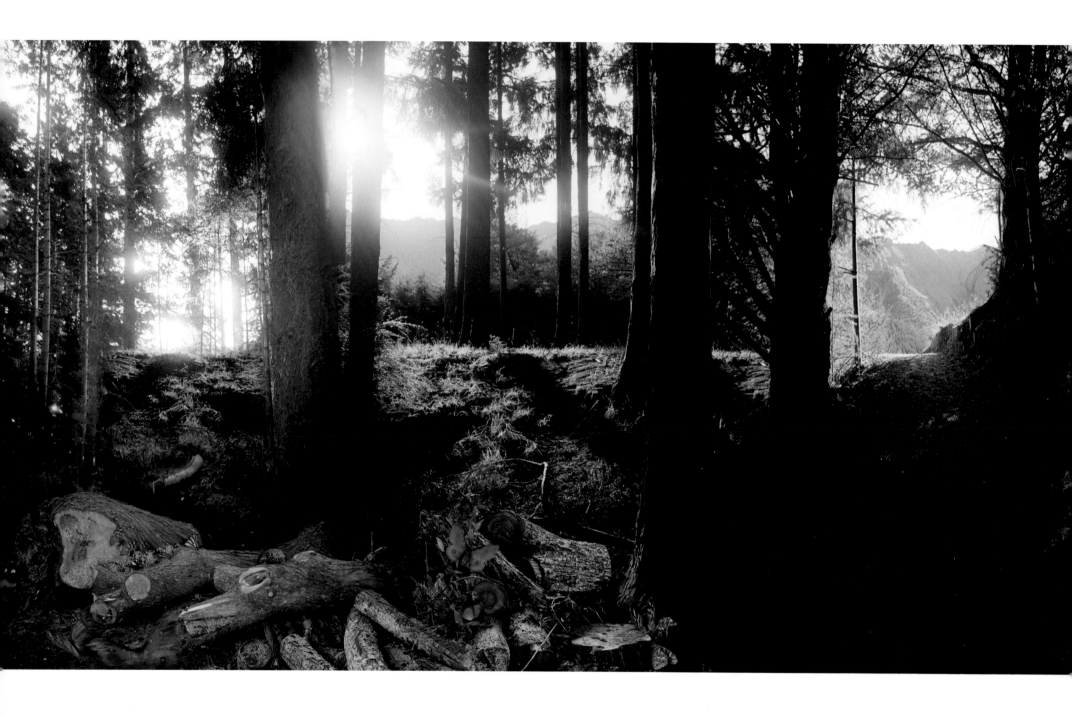

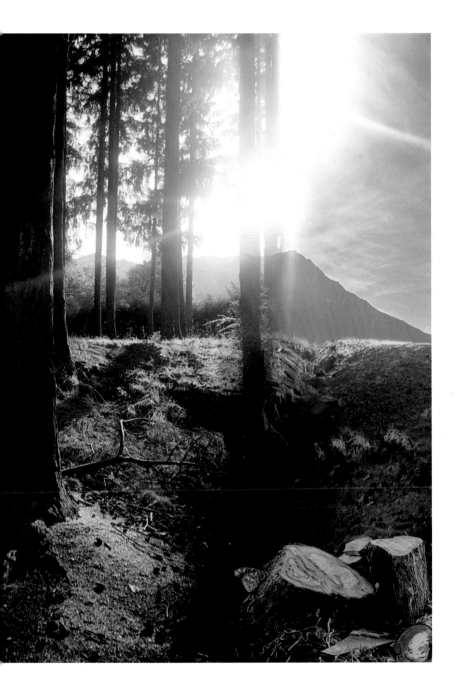

Holly Koons McCullough

The Post-Apocalyptic Sublime:
The Landscapes of
Anthony Goicolea

Whatever is fitted in any sort to excite the ideas of pain and danger, that is to say, whatever is in any sort terrible, or is conversant about terrible objects, or operates in a manner analogous to terror, is a source of the sublime; that is, it is productive of the strongest emotion which the mind is capable of feeling.

– Edmund Burke, 1751

In Anthony Goicolea's *Forest* of 2002 (fig. 1), sunlight streams through a frieze of towering trees into a shadowy wood. A clearing ahead offers a vista of distant mountains, but Goicolea's worm's eye view keeps the viewer pinned to the forest floor, the better to observe the felled wood scattered upon it and the butterflies inexplicably lingering in the area. The chopped wood immediately suggests a narrative: Who was here? Why have they cut these trees? And where have they gone?

Forest is an archetypal example of Goicolea's ideal fairytale setting, both "ominous and beautiful."[2] Drawn from Goicolea's *Landscapes* series of 2002, the work marks a turning point at which the artist began to cast the landscape as a pivotal protagonist in his complex and mysterious narratives. These works straddle the line between reality and fantasy, merging elements drawn from photographs of far-reaching and diverse corners of the world, to create composites of places that exist only in the artist's mind. Only one of the works in the *Landscapes* series includes figures, but all clearly reveal human

Fig. 1
Anthony Goicolea, **Forest**, 2002
Chromogenic print, 28 x 74 inches

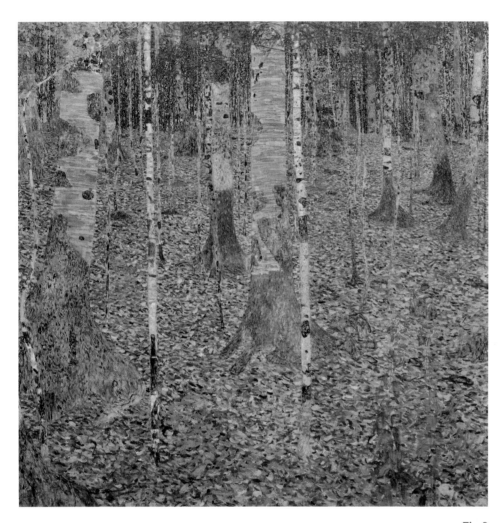

intervention in the natural environment. Many of the works are set in the forest, so central to the fairytales and fables that have impacted Goicolea's artistic vision. The artist has said of these works, "Influenced by the tradition of nature and the sublime in early and mid-nineteenth-century American landscape paintings, my series of landscape photographs treat their environments as hyper-exaggerated frontiers in which remnants of past human interaction are evident through left over traces of people and their activities."[3]

In 1757, Edmund Burke published his famous treatise entitled *A Philosophical Enquiry into the Origin of our Ideas of the Sublime and Beautiful,* which exercised considerable impact on the artists and poets of the emerging Romantic era. The visual artists of the time translated Burke's interpretation of the sublime into paintings exploring the all-powerful, often destructive force of nature, or the awe-inspiring, majestic physicality of creation itself. In the Romantic sublime, nature was worshipped as the magnificent evidence of the Divine Creator, and also feared as a powerful instrument of destruction. Two centuries later, Anthony Goicolea resurrects the sublime in his compelling photographs and drawings exploring invented narratives and mythologies. Yet Goicolea's twenty-first-century sublime is something of a reversal of the earlier pictorial interpretation of the term. It concerns itself less with the power of nature to obliterate human achievements, and more with the power of humans to deface nature. In Goicolea's work, the terror so central to the concept of the sublime is not produced by nature itself, but by humanity's social and physical interactions within it. The landscape is less a source of spiritual succor than a place in which outcasts from a ruined society practice sinister rituals or hoard supplies, leaving only remnants of their destructive impact behind. At their bleakest, Goicolea's sublime landscapes are transformed by the excesses of industry into post-apocalyptic wastelands, becoming a visual metaphor for society's ruin.

Inspiration and Influence

Goicolea's works reward the attentive viewer with a host of influences and associations evoked by the narratives and compositions of his photographs, drawings, and videos. The artist is particularly influenced by nineteenth-century painting, ranging from Romanticism to the Hudson River School to the fin-de-siècle European avant-garde. Goicolea expresses particular admiration for the landscapes of Gustav Klimt and Edouard Vuillard. Both created dense, highly patterned, complex views of forests or cultivated countrysides, in which the element of mystery is maintained and humans are either minor participants or absent entirely. Klimt's paintings of forest interiors, such as *Birch Forest* of 1903 (fig. 2), seem particularly relevant to Goicolea's aims, exhibiting both a magical sensibility and a meticulous attention to detail and texture. Vuillard's landscapes also portray a kind of highly manipulated reality, rooted in observation but carefully manipulated to create dense, textured vistas in which the poetic complexity of nature is magnified.

A natural storyteller, Goicolea is careful never to reveal the full scope of his narratives, leaving viewers to draw their own conclusions about the meaning of his works. He is, in fact, deeply influenced by literature, including fairytales, fables, and in particular, Victorian Gothic novels, in which the landscapes are sometimes as prominent as the characters—one need only consider Heathcliff upon the wild Yorkshire moors. From the beginning, Goicolea has worked in series, allowing the viewer to grasp his narrative scope from a sequence of photographs or drawings, and sometimes a video corresponding to the theme. Likewise, many Victorian novels were published serially; the reader absorbed the story in much-awaited segments. Twentieth-century motion pictures have also exercised considerable influence on Goicolea's work, the concept of moving narratives meshing neatly with the artist's natural creative process.

With regard to the history of photography, Goicolea is certainly aware of the early nineteenth-century attempts to produce composite photographs, like Henry Peach Robinson's *Carolling* (fig. 3). Robinson, along with a handful of other photographers in the Victorian era, created images assembled from multiple negatives, allowing them to present scenes that never truly existed. The contemporary taste for uplifting pastoral scenes informed this bucolic montage, which Robinson carefully sketched out on paper before assembling as a composite photograph. Some decades later, the photomontages of the Surrealists, with their disjunctive and sometimes disturbing juxtapositions, also provided a strong foundation for the photographic assemblage process that the digital revolution would render seamless.

Monumental, staged, and manipulated contemporary photography is not, of course, the exclusive purview of Anthony Goicolea. Canadian artist Jeff Wall (b. 1946) has been producing large-scale, staged photography for decades, creating elaborate sets and casting actors to play roles within his compositions, which are often influenced by canonical paintings from the history of art. Wall's *The Flooded Grave* (fig. 4) provides an instructive comparison with Goicolea's work. Wall presents an expansive, well-cultivated cemetery landscape, with a freshly-dug hole for a new grave looming in the foreground. The grave is flooded with water, and, more remarkably, supports a magnificent population of starfish, anemones, sea urchins, and other marine life. An intricately crafted digital montage of seventy-five images, including photographs of two different cemeteries in the artist's hometown of Vancouver as well as extensive studio shots, *The Flooded Grave* took two years to complete.

Fig. 3
Henry Peach Robinson
(British, 1830-1901)
Carolling, 1890
Photogravure
4 1/2 x 7 1/8 inches
Seattle Art Museum
Mary Arrington Small Estate Acquisition Fund, 85.241.2.1

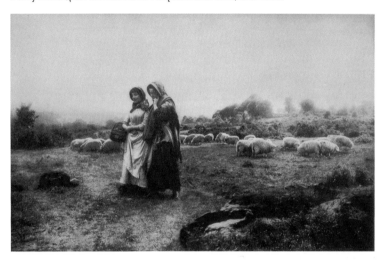

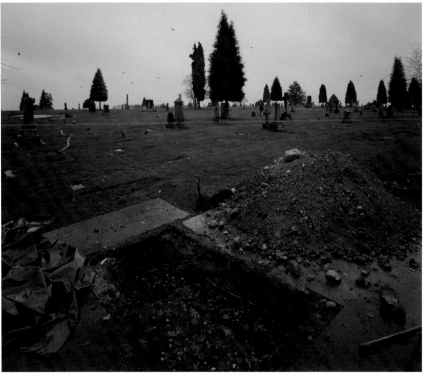

Fig. 4
Jeff Wall (Canadian, b. 1946)
The Flooded Grave, 1998-2000
Transparency in lightbox
89 15/16 x 111 inches
© Jeff Wall
Courtesy of the Artist

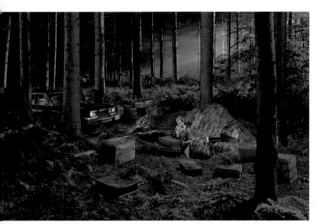

Even more self-consciously theatrical is the work of Gregory Crewdson (b. 1962), who is best known for expansive photographs probing the private disaffections of small-town American life. Crewdson's frozen, puzzling narratives are frequently compared to paintings by Edward Hopper or the cinematography of David Lynch. As with Wall's work, Crewdson's images involve complex on-site shoots with a full production crew, as well as extensive digital editing and compositing in post-production. His untitled image of a man in the woods (fig. 5) can be compared with Goicolea's *Corn Field,* from the *Landscapes* series (fig. 6). Although devoid of figures, Goicolea's image of a darkened cornfield, lit by the headlights of two vehicles, is clearly the scene of some kind of clandestine action. Suitcases full of uniforms line the edge of the cornfield. In Crewdson's image, by contrast, the action of the spotlit figure in the excavated hole, who has unearthed a number of hidden trunks and suitcases, is central to the narrative. The mysterious contents of the trunks, and the setting itself, are less critical.

Goicolea (b. 1971), the youngest of these artists, is working within a now-established tradition of large-scale, staged, and digitally composed narrative imagery. His contribution to the field is differentiated by several factors. Goicolea's particular themes—of male adolescent rituals and brutality, of heritage and identity, and of the co-dependent and often dysfunctional relationship between humanity and nature—have been successfully developed across a variety of media. His photographs are offset and enhanced by his dreamlike, multi-layered drawings, and his videos develop the full cinematic potential of his narratives. With specific regard to landscape,

Goicolea's magical, apocalyptic, or disfigured landscapes function independently, carrying the narrative with little need for figures. Over the course of his career, landscape has become for Goicolea more than mere set or mood-producing agent; as altered by human intervention, it has become an end in itself.

Landscape as Stage

In his early photographs and videos, Goicolea conceived of the landscape as a set upon which to stage the elaborate and mysterious rites carried out by youthful denizens, often clones of himself. In *Ash Wednesday* (plate 2) from the *Detention* series of 2001-02, for instance, numerous adolescent boys in boots and yellow rain slickers trod through a dense forest of ash trees. Theatrically lit and arranged in a kind of frieze, they carry a long stick upon which a hapless youth is bound hand and foot. Literary and religious references abound in Goicolea's work; in this case, the title references the beginning of Lent and the mass in which participants are marked with ashes to remind them of their mortality. The dense forest sets the mood for this ominous scene of impending doom. The aftermath of this narrative may be referenced in *Grave Diggers* (plate 5), a monumental image from the same series portraying the schoolboys (Goicolea himself) digging a hole at the edge of the wood, outside of a fenced complex. In this work, several of the figures are truncated, leaving the focus largely on the landscape and its menacing depression, more a quixotic series of steps than a hole. The area is surrounded by quantities of chopped wood, a metaphor for destruction and mortality.

In other works, the landscape is less a mere mood-setting stage than the site of civilization itself, such as it is. In the *Shelter* series of 2004-05, Goicolea revisits the schoolboys, now perhaps slightly older and therefore potentially more dangerous, in a group of monumental photographs that depict fantastic natural environments, tentatively inhabited by the uniformed and masked boys. In *Tree Dwellers* (plate 17), a colossal, highly manipulated tree, formed

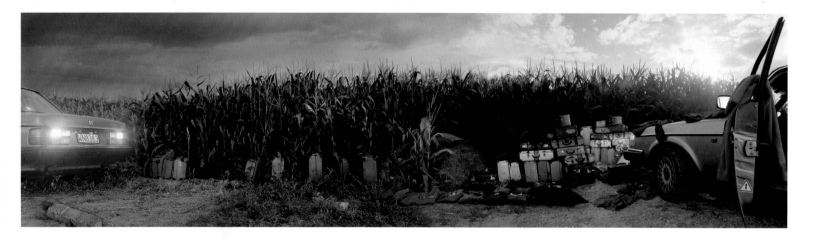

Fig. 6
Anthony Goicolea
Corn Field, 2002
Chromogenic print
22 x 78 inches

Fig. 7
Anthony Goicolea
Campsite, 2005
Chromogenic print
40 x 69 inches

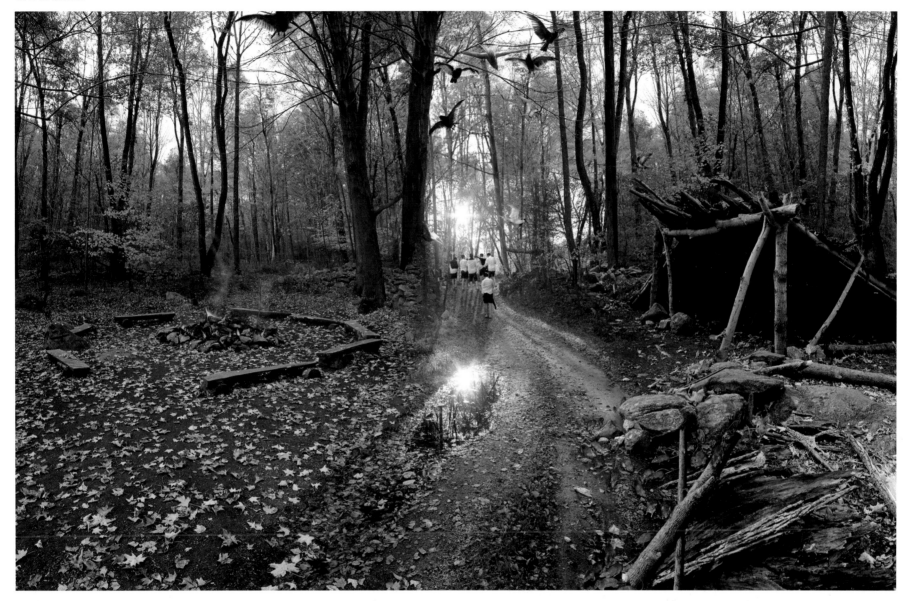

of a dense entanglement of trunks and exposed roots, anchors the center of the image. Within this arboreal complex, the young men have constructed a series of shanties, tenuously perched. This tree-village is situated within the midst of a bucolic, grassy clearing; piles of roots and branches severed in its creation punctuate the grassy expanse. In the far distance, barely visible, cows graze peacefully. That there is a sinister subtext to this image is evidenced by many details—the masked figures themselves, the piles of destroyed wood, the strange village—and yet the scene is rooted in the pastoral.

In the *Shelter* series, the landscapes dominate and engulf their inhabitants, whom Goicolea describes as "outcasts or refugees from society."[4] The lean-

tos, huts, tree houses, caves, and cardboard forts they construct are makeshift, desperate dwellings, emphasizing the marginal social status of their creators. In *Campsite* (fig. 7), several schoolboys in short trousers, their shirts soaked through from rain, make their way through a magnificent autumnal forest in the early light of morning. The campsite they have recently abandoned, consisting of a rugged timber lean-to, some kindling, and a still-burning campfire, is prominently displayed in the foreground. A lover of meticulous, often hidden detail, Goicolea suggests the rapid retrenchment of the forest wilderness, crudely altered by humans to meet basic needs, in the wake of the decampment. Amongst the kindling and decaying logs in the foreground, a

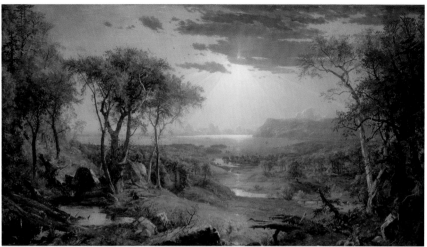

disconcerting number of rodents scurry about, perhaps seeking the remnants of a meal. Far over the heads of the departing boys, owls and barn swallows swoop through the air, as if reclaiming the now-vacated space.

Goicolea's increasing emphasis on the landscape coincided with his growing interest in historical American landscapes. *Campsite*, for instance, can be compared with grandiose Hudson River School pictures, like Jasper Francis Cropsey's *Autumn—On The Hudson River* of 1860 (fig. 8). Goicolea's photograph shares several common elements with the earlier landscape: splendid autumnal foliage, a low-hanging sun, streaming rays of light, a reflective body of water, rocky outcroppings, and craggy logs. *Campsite* also shares with the Cropsey an awe-inspiring vastness that is associated with the sublime. Vistas, though they occur in Goicolea's work, are not typical—usually the viewer is at ground level, immersed in the dense, forested scenery. Goicolea has absorbed the grandeur and sublimity of the Hudson River School tradition but has subverted it, supplanting its spiritual fervor and sense of promise with destruction and moral ambiguity, if not evil.

In another work from the *Shelter* series, figures are absent entirely, signaling Goicolea's shift from cast-driven narratives to those that rely exclusively upon the landscape, and the vestiges of human existence within it, to carry meaning. *Ghost Ship* (fig. 9) is a haunting image of a strange, circular inlet of the ocean, a harbor to no less than six wrecked or rotting boats—it is, in essence, a marine graveyard. In the middle of the inlet stands a small island, seemingly assembled from rocks and detritus. A single tree springs from the soil, its meager branches supporting a couple of shoddily-assembled shanties. Completing the strange effect, two wiry branches of the tree are strung with athletic shoes, presumably belonging to the inhabitants, or one-time inhabitants, of the strange island and its tree house.

Landscape as Narrative

It is less the landscape itself than its near-destruction by humans that characterizes Goicolea's *Almost Safe* series. Gone are the lush autumnal colors and summer greens of the *Shelter* works; vanished, too, are their youthful if sinister inhabitants. These stark, black-and-white photographs portray post-apocalyptic visions of a devastated society. *Smoke Stack* (plate 31), for instance, presents a bird's eye view of a composite maze of nineteenth-century rooftops, whose chimneys belch filth into the brooding sky, obscuring the sun. Goicolea describes the work as "Dickensian,"[5] and indeed, the view could easily be that of an unfortunate chimneysweep, right out of a Victorian novel. A soft-focus vignette effect around the top of the image further hints at a bygone era, recalling nineteenth-century photography—a notion soon dispelled by the clear degree of digital manipulation involved. The equally brooding and aptly-named *Deconstruction* (plate 33) portrays the shell of a Communist-bloc-style building, defaced and reduced to the rubble that dominates the foreground of the image. At first glance, the photograph seems to represent a plausible, nearly-documentary view of the detritus of war or some natural calamity—until one notices that the interior rooms exposed by the crumbled façade are slung with hammocks in which anonymous figures slumber. All appear to be elderly, the lingering survivors of a world that is, like they, winding down.

Goicolea creates in the *Almost Safe* series a new, industrial, post-apocalyptic sublime—a terrible vision of the end of civilization in which nature, largely through the vehicle of the gray, brooding sky, mirrors the mood of destruction and hopelessness. In *Low Tide* (plate 32), Goicolea depicts a single elderly woman, seated on a constructed promontory overlooking the ocean. She is dwarfed by the cliffs that overhang the scene, the vast sea stretching out

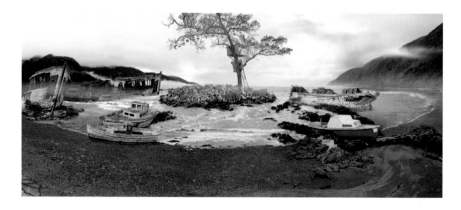

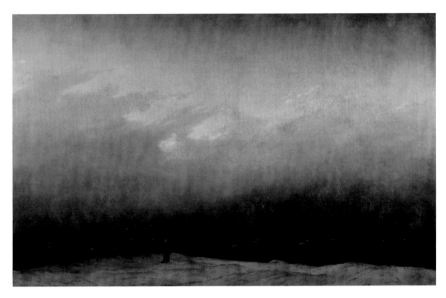

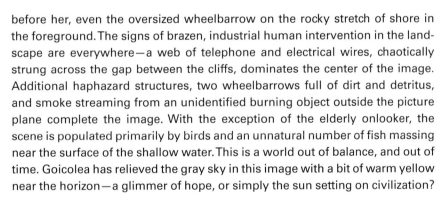

Fig. 10
Caspar David Friedrich
(German, 1774-1840)
Monk by the Sea, 1809
Oil on canvas
43 5/16 x 67 1/2 inches
Nationalgalerie, Staatliche Museen, Berlin, Germany
© Bildarchiv Preussischer Kulturbesitz/Art Resource, NY

Fig. 11
Caspar David Friedrich
(German, 1774-1840)
The Polar Sea, 1823-24
Oil on canvas
38 1/10 x 50 inches
Hamburger Kunsthalle, Hamburg, Germany
© Bildarchiv Preussischer Kulturbesitz/Art Resource, NY

before her, even the oversized wheelbarrow on the rocky stretch of shore in the foreground. The signs of brazen, industrial human intervention in the landscape are everywhere—a web of telephone and electrical wires, chaotically strung across the gap between the cliffs, dominates the center of the image. Additional haphazard structures, two wheelbarrows full of dirt and detritus, and smoke streaming from an unidentified burning object outside the picture plane complete the image. With the exception of the elderly onlooker, the scene is populated primarily by birds and an unnatural number of fish massing near the surface of the shallow water. This is a world out of balance, and out of time. Goicolea has relieved the gray sky in this image with a bit of warm yellow near the horizon—a glimmer of hope, or simply the sun setting on civilization?

Goicolea has affirmed that the *Almost Safe* photographs allude to the history of cinema, including film noir, French new wave, and science fiction films.[6] But he also acknowledges his debt to the nineteenth-century Romantic tradition, in which the element of the sublime—that in nature which inspires fear or awe—is a consistent feature. Caspar David Friedrich's *Monk by the Sea* (fig. 10), an icon of Romantic art, bears comparison with Goicolea's *Low Tide*. Friedrich's diminutive monk, dwarfed by the vast landscape, stands alone beneath a gloomy sky and an endless sea, presumably contemplating his insignificance in the scope of the natural world and doubting the relevance of his faith. Like the elderly woman in *Low Tide,* he grasps his own mortality. In Friedrich's image, however, nature appears immense, powerful, and infinite,

while in Goicolea's photograph, it has been permanently marred by uneasy human intervention. The communion with awe-inspiring nature, so critical to Romantic painters, is impeded in Goicolea's work by post-industrial disfigurement. Yet the strange proliferation of fish and the watchful pigeons perched on the wires hint at the possible regeneration of the natural order.

Goicolea's landscapes often feature snow, which he describes as "a beautiful, temporary recording device for nature."[7] Aesthetically, the artist considers snow an equalizing device that provides uniformity while maintaining a sense of mystery. In *Guardian* (plate 35), the shifting and irrational concrete and stone platforms that comprise the constructed landscape, visible beneath the snow, recall the jagged, converging plates of ice in Friedrich's *The Polar Sea* (fig. 11). Both works portray harsh, powerful Arctic landscapes, but in Goicolea's photograph, nature's grandeur is disfigured by the indignities of colonization. The human presence is indicated by the boxy, brightly colored row houses in the background, the snow-covered pelts hanging from a ragged platform, the abandoned sled, and many trails of footsteps recorded in the snow. Yet the work is populated solely by sled dogs, which are chained and unchained, barking and sleeping, and generally taking the place of human characters. The focus on these dogs—so close in appearance to wolves—is, besides the remote, frozen tundra itself, another indicator of civilization run amuck, growing ever nearer to the savage.

Fig. 12
Anthony Goicolea
The Arsonist's Son, 2007
Graphite, ink, acrylic, and gold leaf on Mylar
75 x 122 inches

The Integral Landscape: Goicolea's Drawings

Unlike his photographs, Goicolea's drawings are rarely pure landscapes; the narrative is still largely carried through the action of figures. Yet the artist's sensual, multi-layered drawings portray a different interaction between landscape and figure—that of actual co-mingling. In works like *Fleeing* (plate 22), depicting a group of children running through a dense thicket of trees, the trunks and branches appear to pierce or overlap the translucent figures, fusing arboreal and human limbs. The swarms of real horseflies embedded in the surface of the work illustrate the terror of the retreat and the perils of the wood. The interpenetration of figures and trees is characteristic of many of Goicolea's drawings. In the portentous work entitled *The Arsonist's Son* (fig. 12), the father's torso is transparent, his opaque coat revealing the landscape of sparse trees in the background. The figure is literally inseparable from the landscape itself, his ghostly presence completely merging with his surroundings. In another drawing, *Red Sky* (fig. 13), two boys cling desperately to the bare branches of a tree. The boys become part of the structure and expanse of the tree itself, integrated along with a flock of nesting crows. The threatening implications of the red sky are furthered by a sinister pair of arms that rise from below the picture frame, insistently pulling on the ankle of one of the boys.

Goicolea's drawings, like *Defectors* of 2005 (plate 23), often depict refugees moving through or seeking shelter within the forest—or sometimes figures trapped by floods, making their way on bikes or canoes through the deluge. In *Defectors*, a boy pushing another child in a wheelbarrow—an image that recalls the refugee processions of William Kentridge—presents the only color in an otherwise stark composition. Such works can be compared to drawings by Goicolea's contemporary, Robyn O'Neil (b. 1977), known for her meticulous, large-scale narrative drawings of snowy landscapes interspersed with figures (often uniformed) engaged in menacing rituals (fig. 14). O'Neil's subjects, however, are essentially distinct from the inhospitable environment they inhabit. Goicolea's drawings, often rendered on layered sheets of Mylar, create an impression of depth and opacity that blends background and foreground, protagonist and setting, in such a way that the figure and its environment become inseparable, and the co-dependent nature of their relationship is revealed.

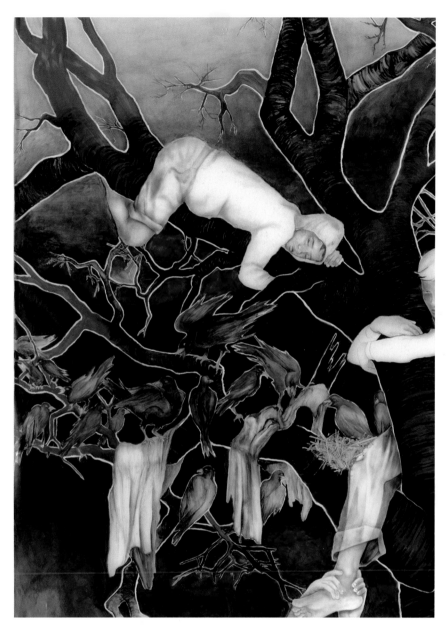

Fig. 13
Anthony Goicolea
Red Sky, 2004
Graphite, ink and Acrylic and straw on Mylar
84 X 60

Fig. 14
Robyn O'Neil (American, b. 1977)
And The Individuals Will Rise Above, 2005
Graphite on paper
11 7/10 x 9 3/5 inches
© Robyn O'Neil
Image courtesy of The New York Times Company

Landscape as Fantasy

Some of Goicolea's landscapes appear, at first glance, plausibly real; others are more overtly fictional. In the case of his photographs, which are seamlessly constructed from multiple images of varying and often far-flung corners of the planet, they are assemblages of an idea of a place, a geographical fantasy. The artist elaborates upon his process:

When I photograph a place, I take pictures of all the elements that contribute to the feeling of a space. Oftentimes, the sky is taken on a separate day, trees are collected from nearby locations, ground cover spans several miles...but it is all combined and composited into one image that communicates the "idea" of a place even though it is not accurate documentation.[8]

Cherry Island (plate 12) is unique within the artist's oeuvre for its campy cheerfulness, but at its core, the image harbors the surreal qualities characteristic of Goicolea's work. An idyllic little park, complete with white wrought-iron garden furniture, is overrun by dozens of rabbits, ducks, chickens, and doves, so numerous as to suggest some kind of genetic experiment or breeding program gone awry. A tongue-in-cheek riff on the pastoral mode, *Cherry Island* is a contrast to Goicolea's typically brooding landscapes. The cloying sweetness and artificiality of this environment represent the flip side of the industrial desecration portrayed in other Goicolea works—and it is an equally unsettling prospect. *Cherry Island* is a cartoon, calling to mind the island where Mary Poppins and Burt have tea on their imaginative trip through one of Burt's chalk drawings—minus the dancing penguins.

On the other end of the mood spectrum, Goicolea's *Black House* (plate 49) portrays a scene nearly as improbable as that of *Cherry Island*—and, like it, featuring animals standing in for human figures. A pack of large dogs trots through a seemingly endless, snow-swept cemetery filled with hundreds of graves marked by white crosses and low black headstones. Long, austere warehouse buildings in the background complete the foreboding scene. It is a self-consciously chilling work, and, like many of Goicolea's images, it feels cinematic, a film still with dogs cast in place of human actors. The multitude of graves in the cemetery and the absence of living human figures lead to the inevitable question: do humans still exist in this world?

Landscape as Remnant

In his work since 2002, Goicolea has increasingly produced photographs of landscapes that reveal human interaction in the environment, but avoid actual humans. These landscapes function as a kind of record of action now long concluded; according to the artist, they are "exaggerated frontiers in which remnants of past human interaction are evident through leftover traces of people and their activities."[9] An excellent example is *Cliffside* (plate 13), portraying a vertiginous, rocky cliff viewed from the safety of a constructed wall across a chasm of turquoise water. At first glance, it appears to be a straightforward photograph of a striking landscape, until one notices the series of meandering, wooden walkways that cling to the rock face, leading downward to no destination in particular. These vestiges of a vanished society summon the intrigue of prehistoric cave paintings, crop circles, or other awe-inspiring ruins and relics of mysterious civilizations. The idiosyncratic walkways—along with the impressive cliff formation itself, the rugged, blasted trees that line the mountaintop, and the dense fog rolling in—invoke the sublime, with its components of mystery, power, and awe.

Goicolea has remarked, "Within these landscapes, seemingly realistic environments provide physical evidence and visual proof of an ongoing past narrative. The photographs use the aesthetics and beauty inherent to nature and the sublime to create an exaggerated pastoral scene which bears the imprint of time."[10] The artist's most recent works, from his *DecemberMay* series, continue to focus on the remnants of human action upon the landscape. *Territorial* (plate 48), for instance, portrays a boulder in the midst of a snowy forest, inhabited only by a flock of crows who busily flap about, their voluminous nests precariously perched among the tree branches. But evidence of human presence in this landscape is clear enough; the face of the boulder is covered in colorful, crude, and indecipherable graffiti of the kind one would expect to see in a decaying urban environment. Fallen tree limbs are carefully leaned against the rock, placed there at an unknown time by mysteriously absent participants.

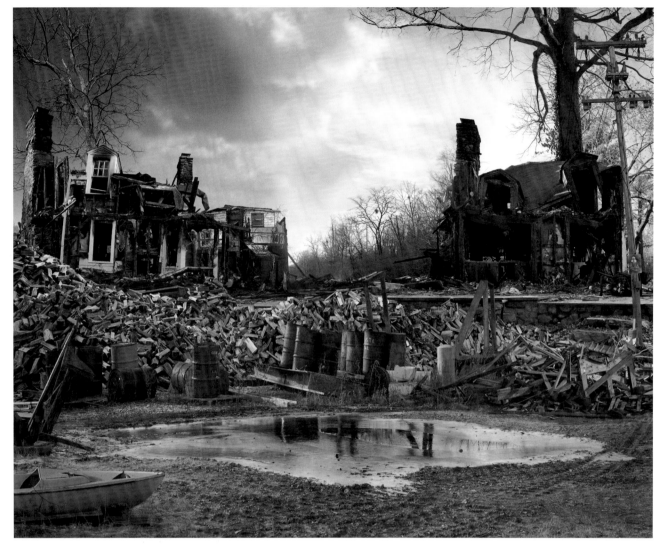

Fig. 15
Anthony Goicolea
Burnt House, 2008
Chromogenic print
70 x 89 3/4 inches

Siamese Twins (plate 46), from the same series, also references urban decay in the two junked cars parked side by side in a clearing in the forest. Glimpsing the cars through a frame of vivid autumn leaves and fern fronds, the viewer assumes a clandestine, if not overtly voyeuristic, perspective. A remarkable bounty of food spills from the nearest car, a sensual and colorful array of fish, pineapples, eggplants, and other perishables—hoarded by and for whom is left to our imagination. This enigmatic still life, which recalls an earlier work from the *Shelter* series, *Still Life with Pig* (plate 20), is another testament to Goicolea's ongoing dialogue with art history. The lavish nature of these displays invokes the tradition of seventeenth-century Dutch and Flemish still life, vanitas pictures signifying the transience of all living things. Such paintings frequently included a dying flower, rotting piece of fruit, or marauding insect to remind the viewer of the vain and fleeting nature of earthly pleasures. Goicolea's reference to historical still life—and its significance as a vanitas and, by extension, a *memento mori*—adds yet another layer of meaning to his work. He has noted of the *DecemberMay* series, "Any comfort offered by the company of others is undermined by a familiar undercurrent of morbidity: fecundity is crippled by futile obsessiveness and decay, paths lead to uncertainty or death, and the spirit world has broken through to our everyday reality."[11]

Goicolea has continued to create figure-based works in recent series such as *Related* and *Once Removed*, exploring his own Cuban heritage. Yet the artist's work has progressed from the multiple self-portrait series of the late 1990s to works that rely increasingly upon landscape to convey their narrative significance. Following the *Almost Safe* series of post-apocalyptic industrial landscapes in 2007, Goicolea produced the sparsely populated forest scenes of *DecemberMay,* in which books, food, and clothing are hoarded in abandoned cars or hastily-built shelters. Perhaps the artist is proposing an inevitable sequence—a civilization in decline that has taken refuge in the forest after some cataclysmic event, and is tentatively starting over? This interpretation is given some credence by Goicolea himself, who notes that young children are introduced into the *DecemberMay* series for the first time, to offer "a sense of renewal and hope for the future."[12]

Goicolea's *Burnt House* (fig. 15) is a tragic monument to a society that has sacrificed itself upon its own endless needs. Two once-commodious homes stand charred behind a wall of rubble and a slick pool of liquid. Given the metal drums that surround the pool, the viewer is tempted to conclude it is oil. Is the universal thirst for oil, then, at the root of this massive de-

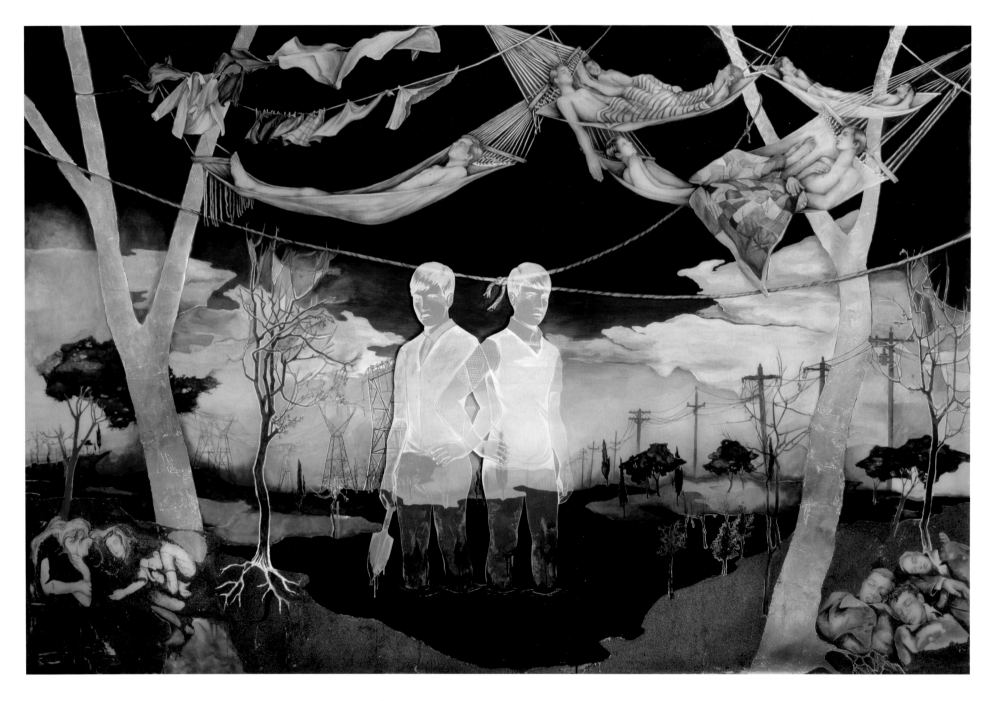

Fig. 16
Anthony Goicolea
Petroleum Dream, 2006
Graphite, ink, acrylic, and gold leaf on Mylar with poppy seeds
92 x 144 inches

Fig. 17
Anthony Goicolea
Tangled I, 2008
Graphite, ink, and acrylic on Mylar
97 x 36 inches

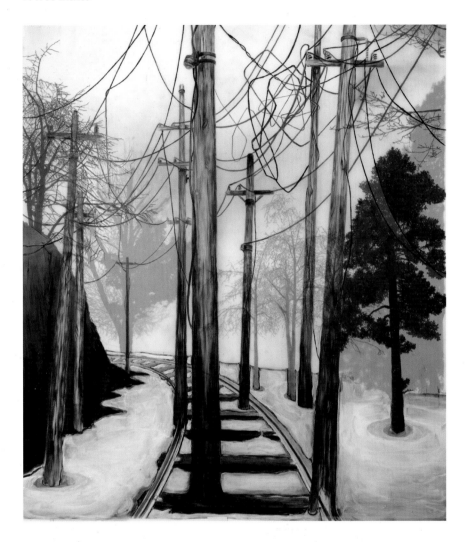

struction? Goicolea has produced a number of photographs and drawings that address the global implications of oil as a commodity; the drawing entitled *Petroleum Dream* (fig. 16) is perhaps one of the most ambitious and hallucinatory. In it, two transparent, ghostly twin boys, harkening back to Goicolea's early characters, stand in a river of black liquid petroleum. They are surrounded by bare, if opulently gilded, trees—now considerably outnumbered by telephone poles and electrical towers and wires. In the foreground, several youths are literally nestled within the sediment, buried in an unconscious state—and above, strung from the leafless trees, are hammocks in which additional youths slumber. Their skin tone ranges from pasty to a poisoned, sickly green. The sky behind them is red and then as black as the pool below. This drawing is analogous to Goicolea's *Almost Safe* photographs—it is a haunting vision of life after environmental catastrophe.

The lingering reality of possible nuclear annihilation, the constant global threat of terrorism, the looming dread of environmental destruction, the savage crimes human beings commit against one another—these contemporary fears seem to find visual expression in Goicolea's sublime, post-apocalyptic universe. The artist's recent landscapes, like *Tangled I* (fig. 17), present chaotic urbanity permeating nature with an impenetrable array of electrical and telephone lines. Human beings, where they appear, exist in relative isolation. Other works present survivalist forest encampments, suggesting a society of refugees addressing basic needs and re-establishing lost rituals—but on a very primitive level, in which human achievements are now no more permanent or opulent than the nests built by the ever-present birds. These works are, in fact, a kind of modern *memento mori*—an apparition of the bleak future we are daily creating, and an injunction to remember our end before it is too late.

Holly Koons McCullough
Director of Collections and Exhibitions
Telfair Museums

1 Adam Phillips, ed. Edmund Burke, *A Philosophical Enquiry into the Origin of our Ideas of the Sublime and Beautiful*, 1757 (Oxford: Oxford University Press, 1998), 50.

2 Email from the artist in response to interview questions, October 5, 2010.

3 Anthony Goicolea, "*Landscapes* Series Statement," accessed October 2, 2010, http://www.anthonygoicolea.com/NewAnthonySite/pages/landstatement.html.

4 Anthony Goicolea, "*Sheltered Life* Statement," accessed October 2, 2010, http://www.anthonygoicolea.com/NewAnthonySite/pages/shelteredstatement.html.

5 Anthony Goicolea, "*Almost Safe* Series Statement," accessed October 2, 2010, http://www.anthonygoicolea.com/NewAnthonySite/pages/almostsafestatement.html.

6 Ibid.

7 Email from the artist in response to interview questions, October 5, 2010.

8 Ibid.

9 Anthony Goicolea, "*Landscapes* Series Statement," accessed October 2, 2010, http://www.anthonygoicolea.com/NewAnthonySite/pages/landstatement.html.

10 Ibid.

11 Anthony Goicolea, "*DecemberMay* Statement," accessed October 2, 2010, http://www.anthonygoicolea.com/NewAnthonySite/dec_may/december_may_statement.html.

12 Ibid.

goicolea

Alter Ego: A Decade of Work by Anthony Goicolea

Plate 1
Class Picture, 1999
Chromogenic print
42 x 40 inches
Collection of Fred and Ampy Cox

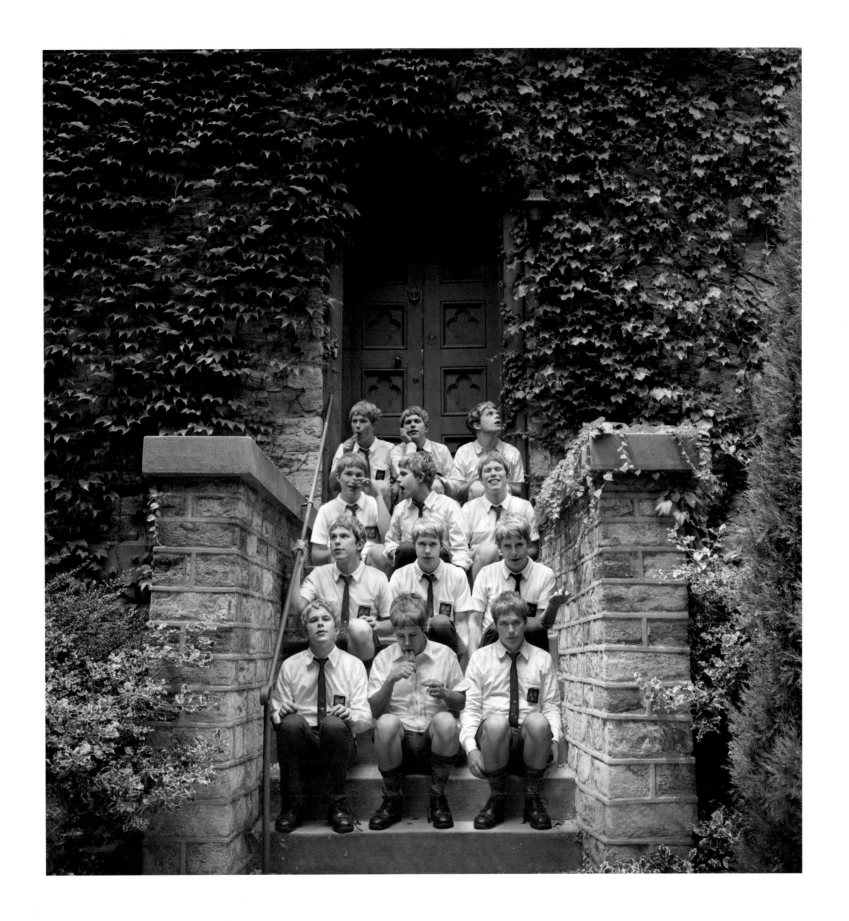

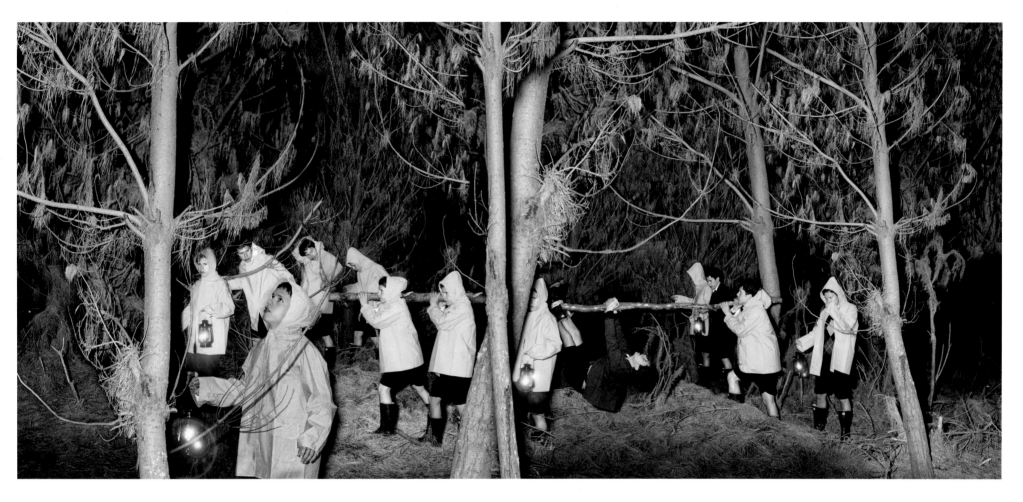

Plate 2
Ash Wednesday, 2001
Chromogenic print, mounted on Sintra and laminated
40 x 89 inches
Courtesy of 21c Museum and Collection of Laura Lee Brown and Steve Wilson,
Louisville, KY

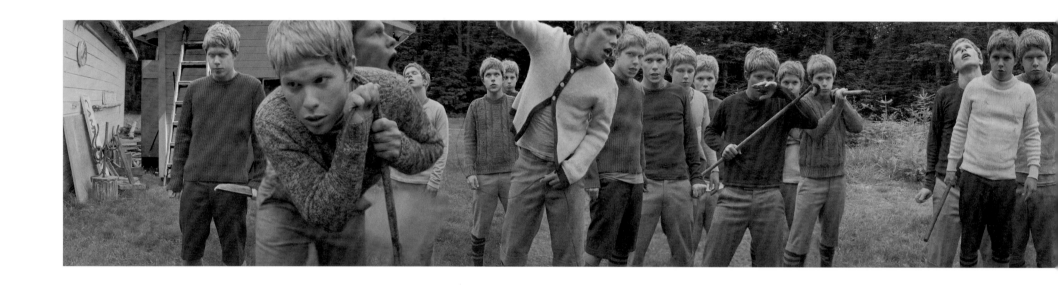

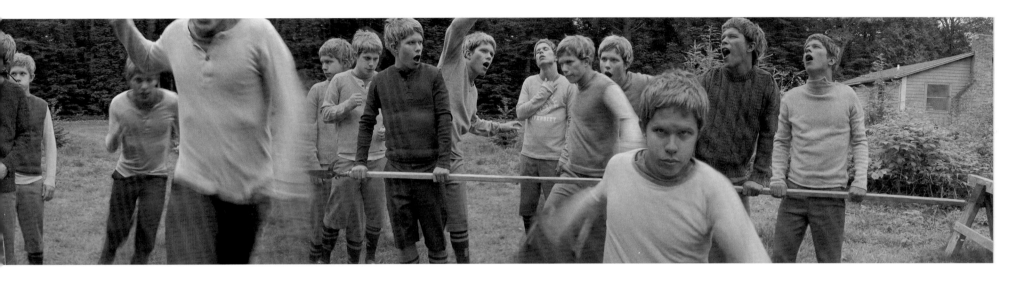

Plate 3
Warriors, 2001
Chromogenic print, mounted on Sintra board
30 x 276 inches
Courtesy of 21c Museum and Collection of Laura Lee Brown and Steve Wilson,
Louisville, KY

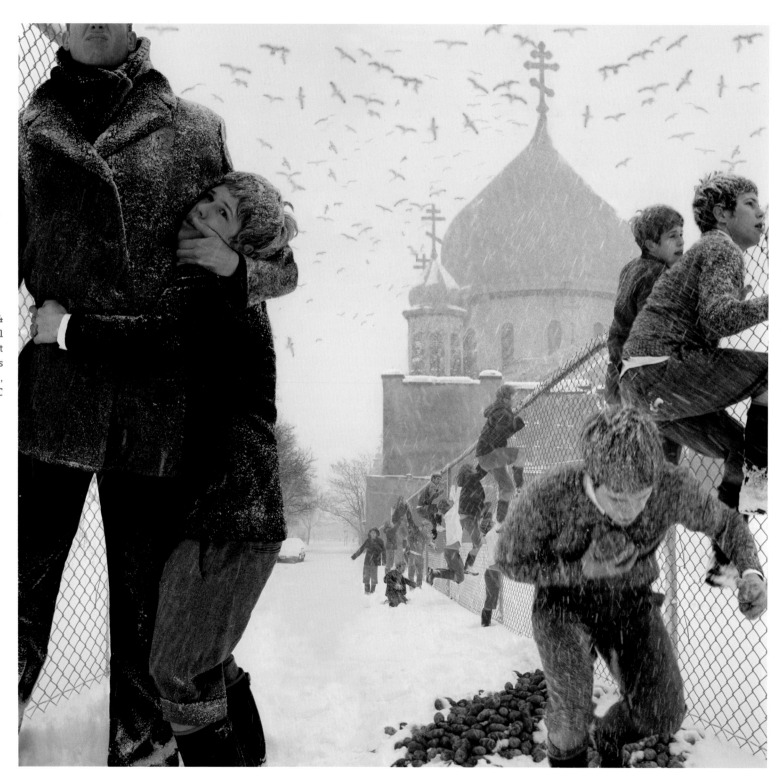

Plate 4
Blizzard, 2001
Chromogenic print
40 x 42 inches
Collection of Allen G. Thomas Jr.,
Wilson, NC

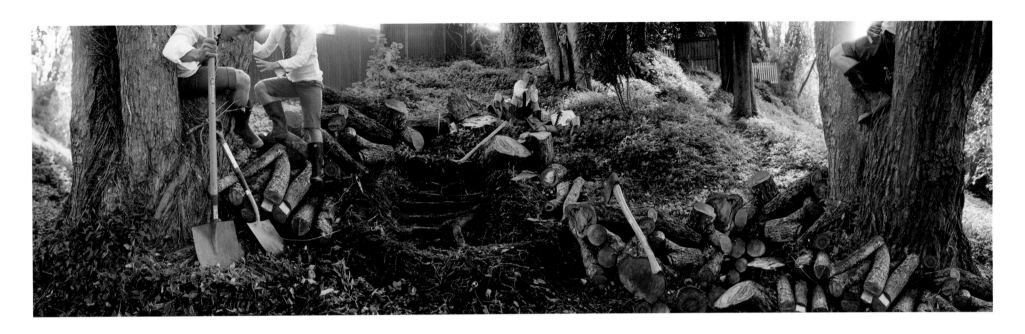

Plate 5
Grave Diggers, 2001
Chromogenic print
30 x 102 inches
Courtesy of the Artist and Postmasters Gallery, New York, NY

Plate 6
Pool Pushers, 2001
Chromogenic print
71 x 100 inches
Collection of Dr. Carlos Garcia-Velez, Raleigh, NC

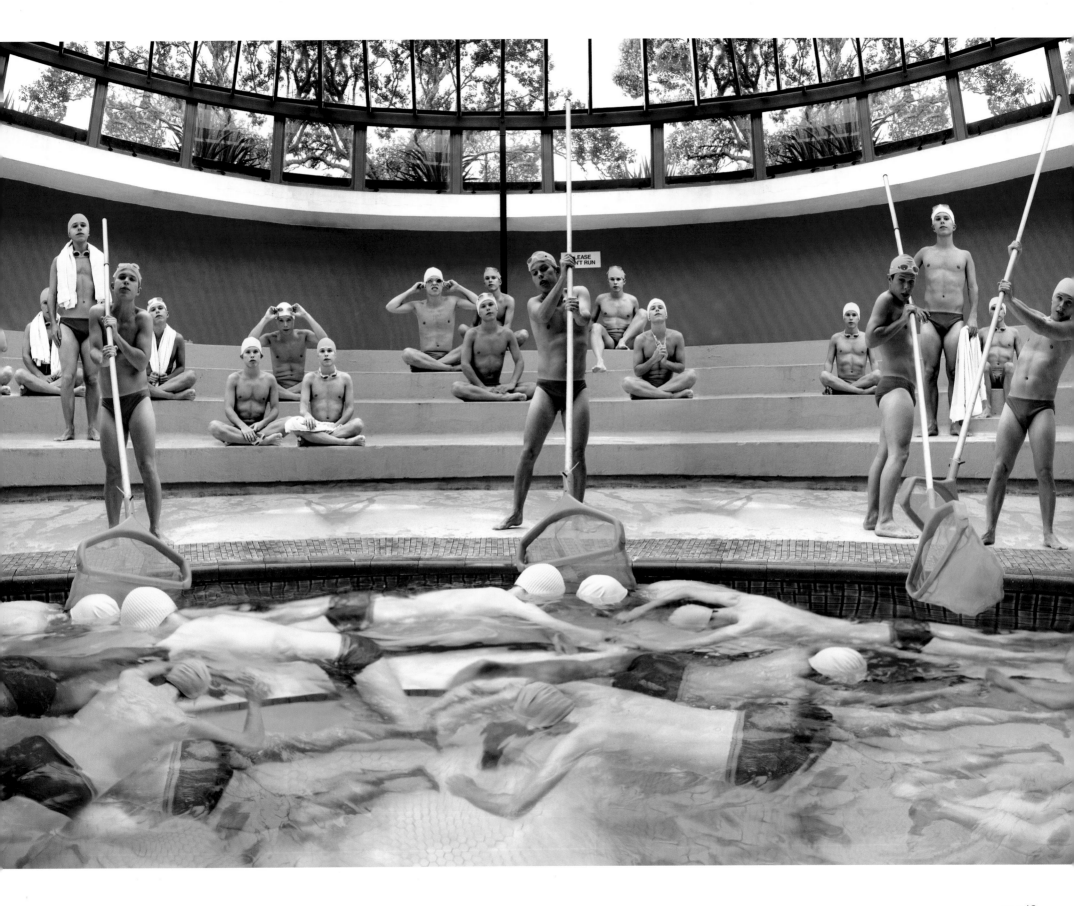

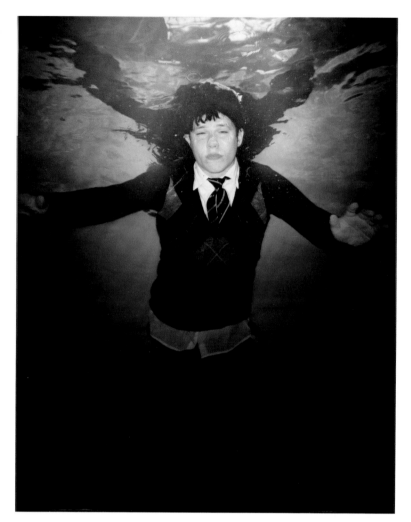

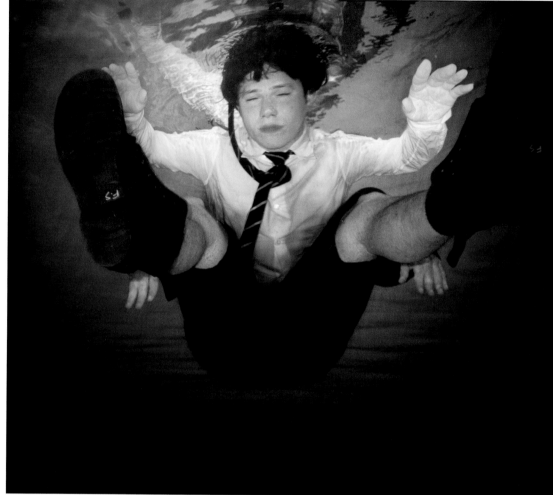

Plate 7
Under I, 2001
Chromogenic print
20 x 16 inches
Courtesy of 21c Museum and Collection of
Laura Lee Brown and Steve Wilson,
Louisville, KY

Plate 8
Under II, 2001
Chromogenic print
20 x 24 inches
Courtesy of 21c Museum and Collection of
Laura Lee Brown and Steve Wilson,
Louisville, KY

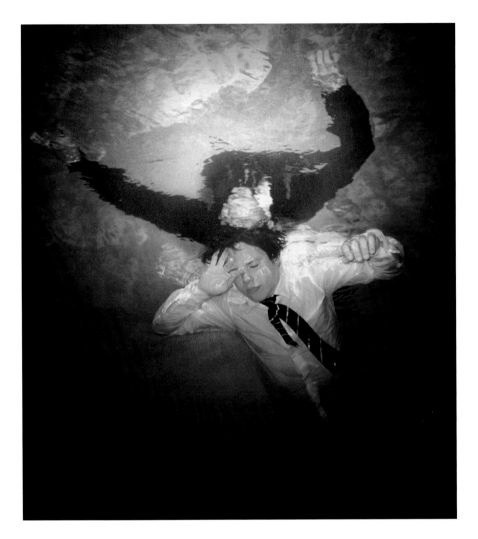

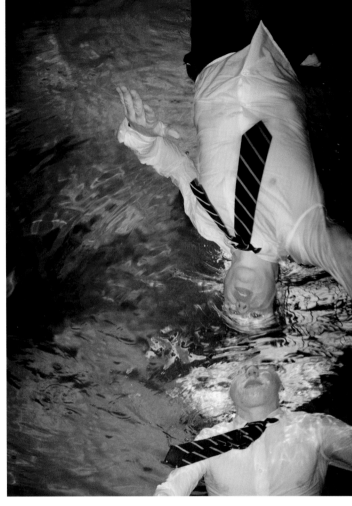

Plate 9
Under III, 2001
Chromogenic print
20 x 18 inches
Courtesy of 21c Museum and Collection of
Laura Lee Brown and Steve Wilson,
Louisville, KY

Plate 10
Under V, 2001
Chromogenic print
20 x 15 inches
Courtesy of 21c Museum and Collection of
Laura Lee Brown and Steve Wilson,
Louisville, KY

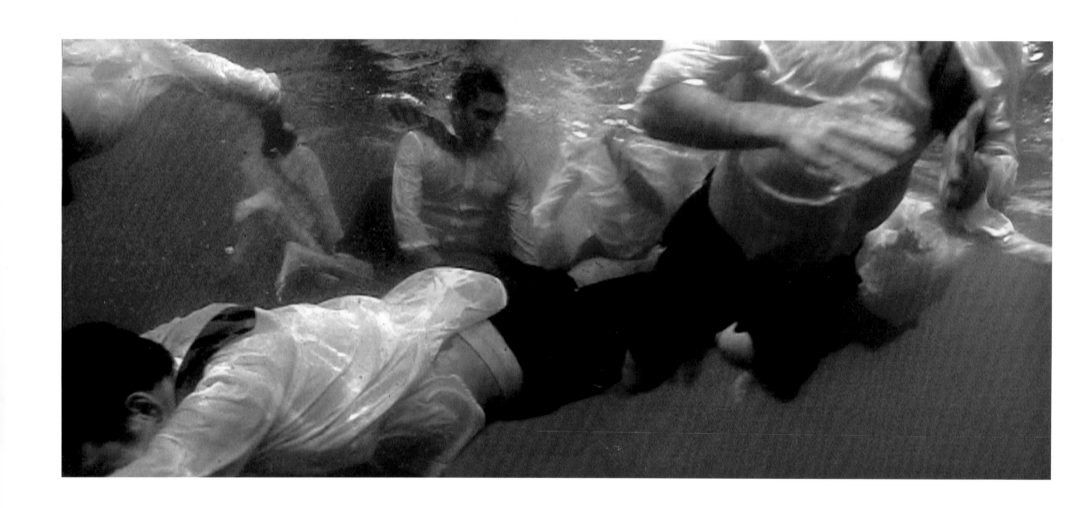

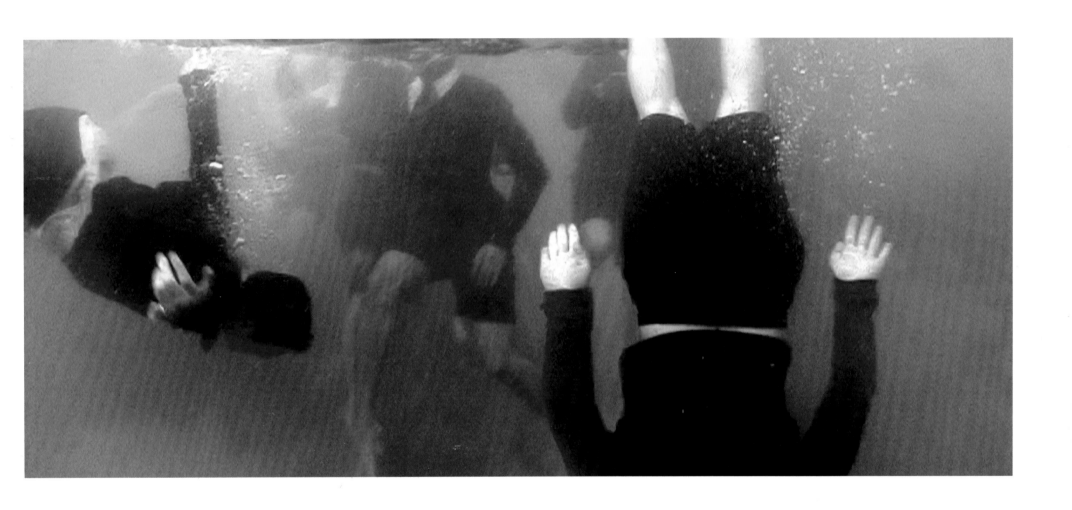

Plates 11a and 11b
Amphibians, 2002
Single-channel DVD
Courtesy of Postmasters Gallery, New York, NY

Plate 12
Cherry Island, 2002
Chromogenic print
27 x 71 inches
Collection of Mr. Edsel Williams

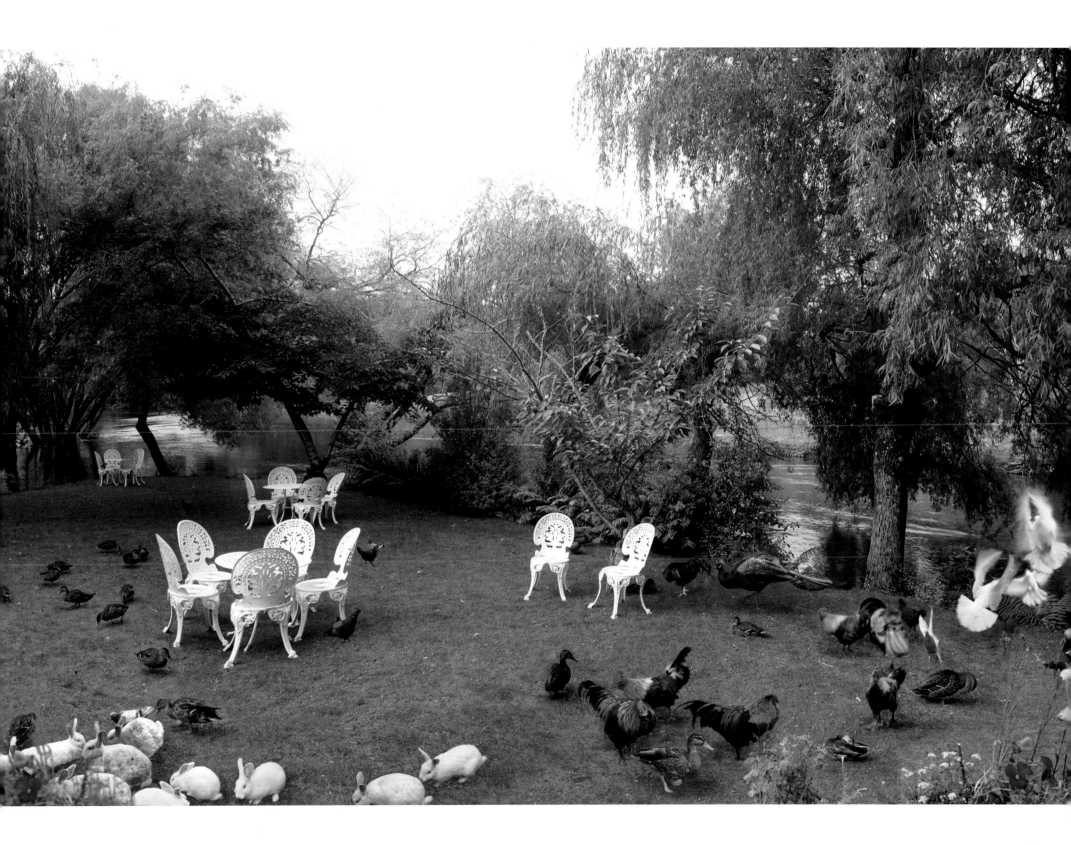

Plate 13
Cliffside, 2002
Chromogenic print
49 x 25 inches
Collection of Jennifer Dalton and Wellington Fan

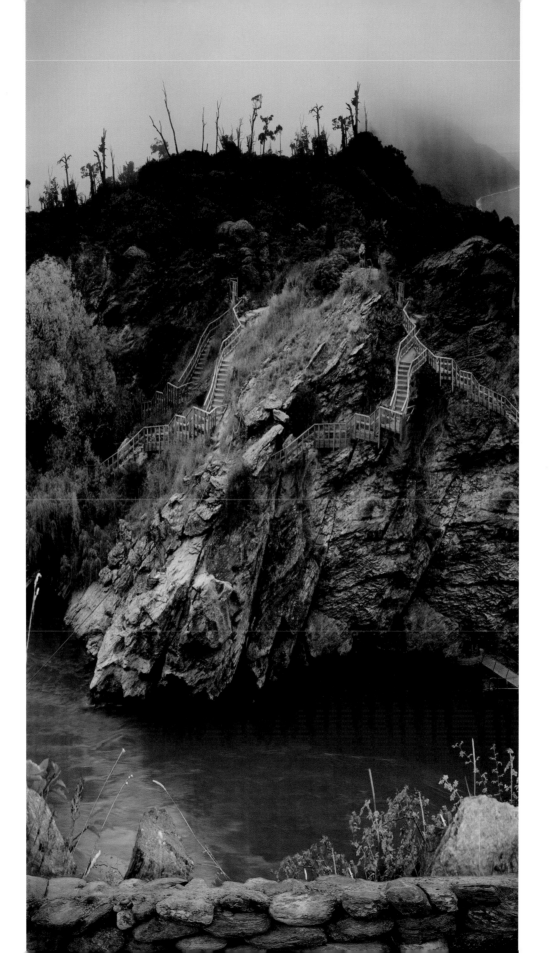

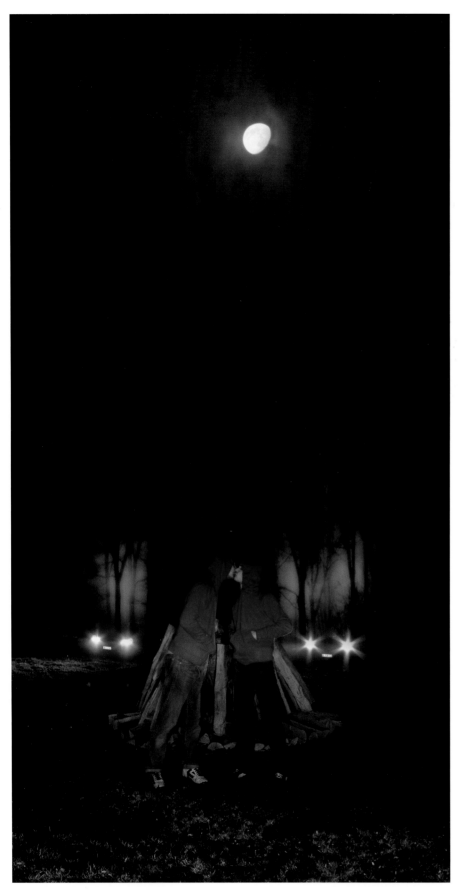

Plate 14
Midnight Kiss, 2004
Chromogenic print, mounted on aluminum
and laminated with Plexiglas
76 3/16 x 40 3/16 inches
Collection of Allen G. Thomas Jr., Wilson, NC

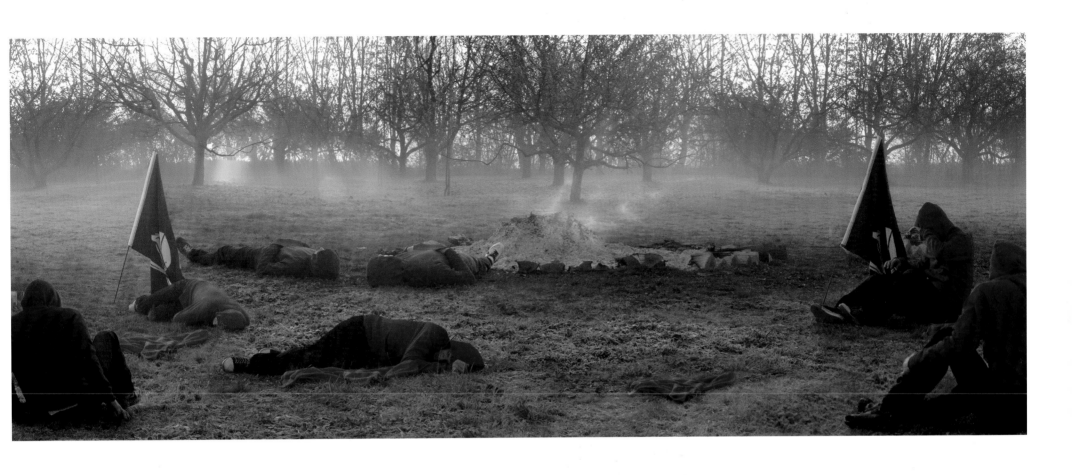

Plate 15
Morning Sleep, 2004
Chromogenic print, mounted on aluminum and laminated
40 x 105 inches
North Carolina Museum of Art,
purchased with funds from June Ficklen, 2007.3

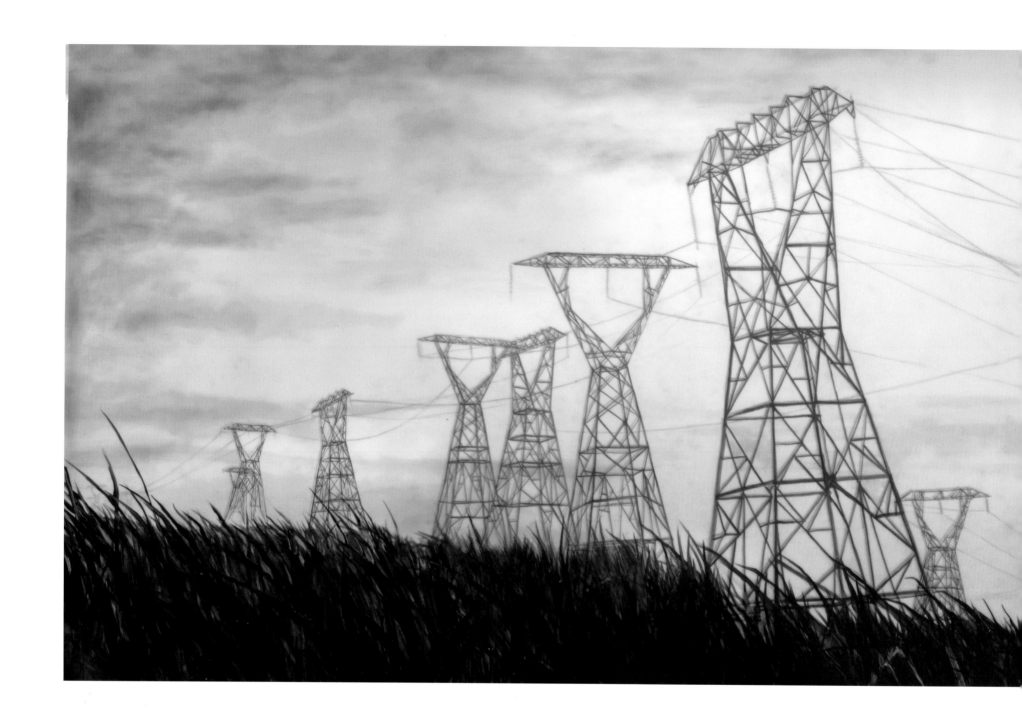

Plate 16
Cat's Cradle, 2004
Graphite, ink, and acrylic on Mylar
23 1/2 x 77 3/4 inches
Collection of Allen G. Thomas Jr., Wilson, NC

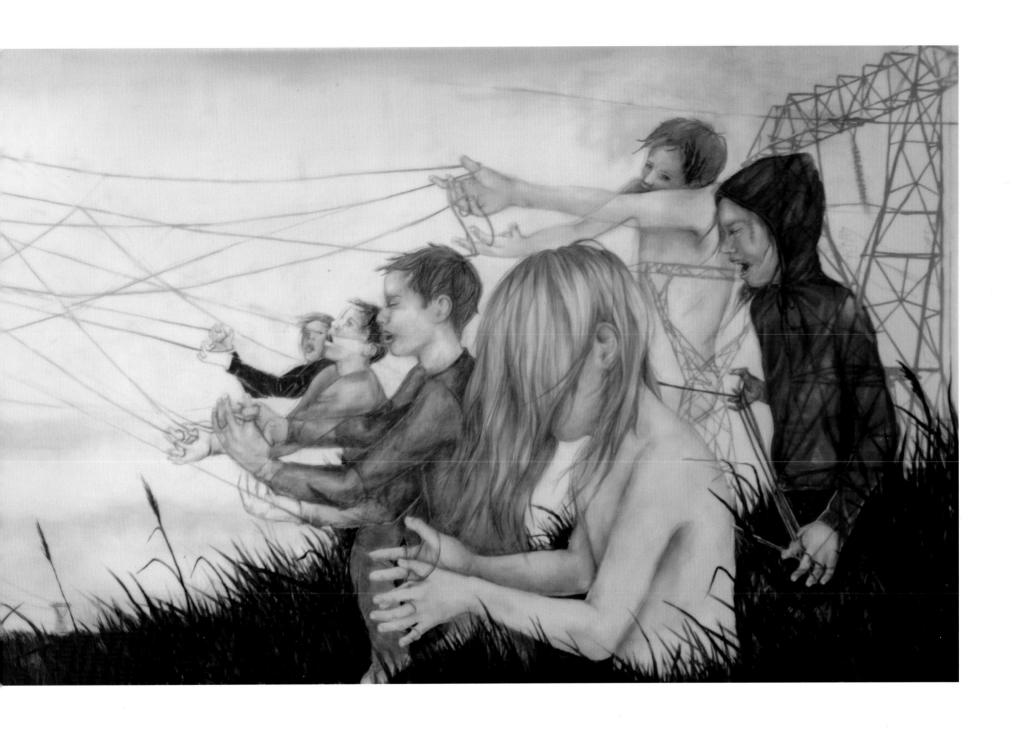

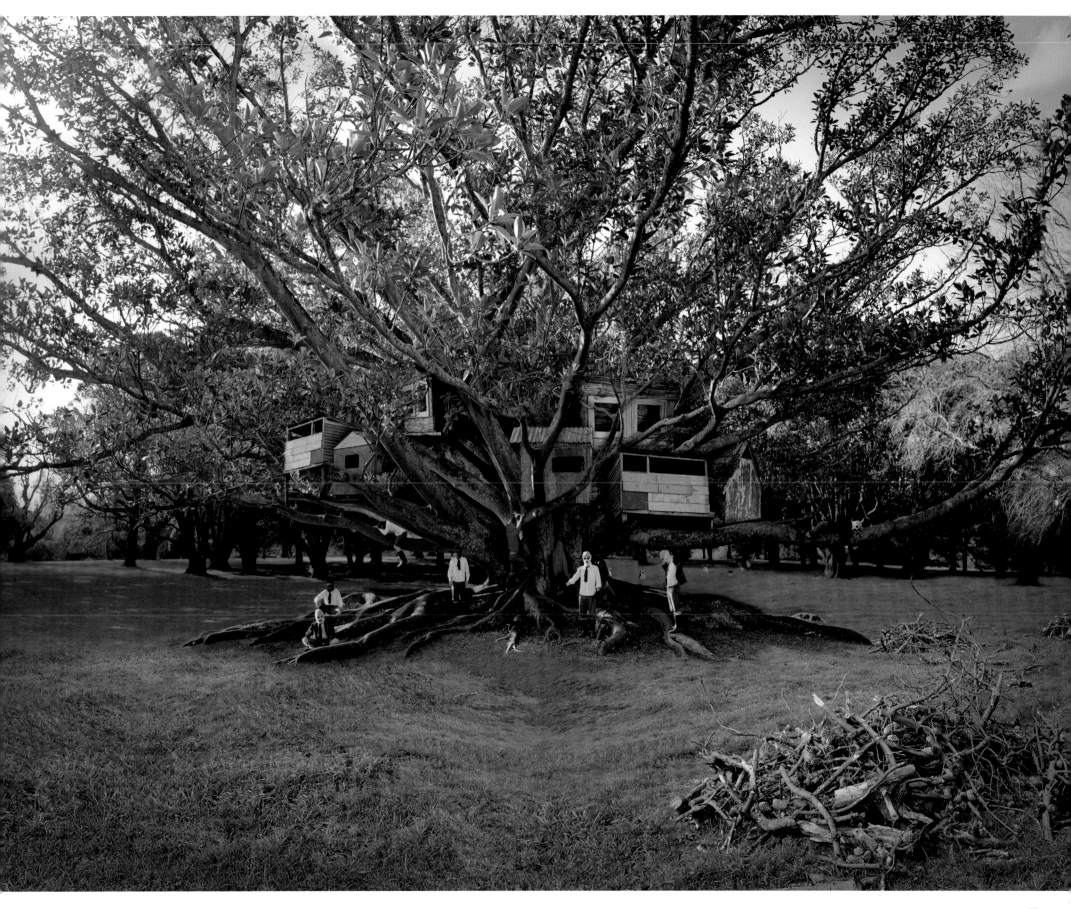

Plate 18
Lake, 2004
Chromogenic print
72 x 72 inches
Courtesy of 21c Museum and Collection of
Laura Lee Brown and Steve Wilson,
Louisville, KY

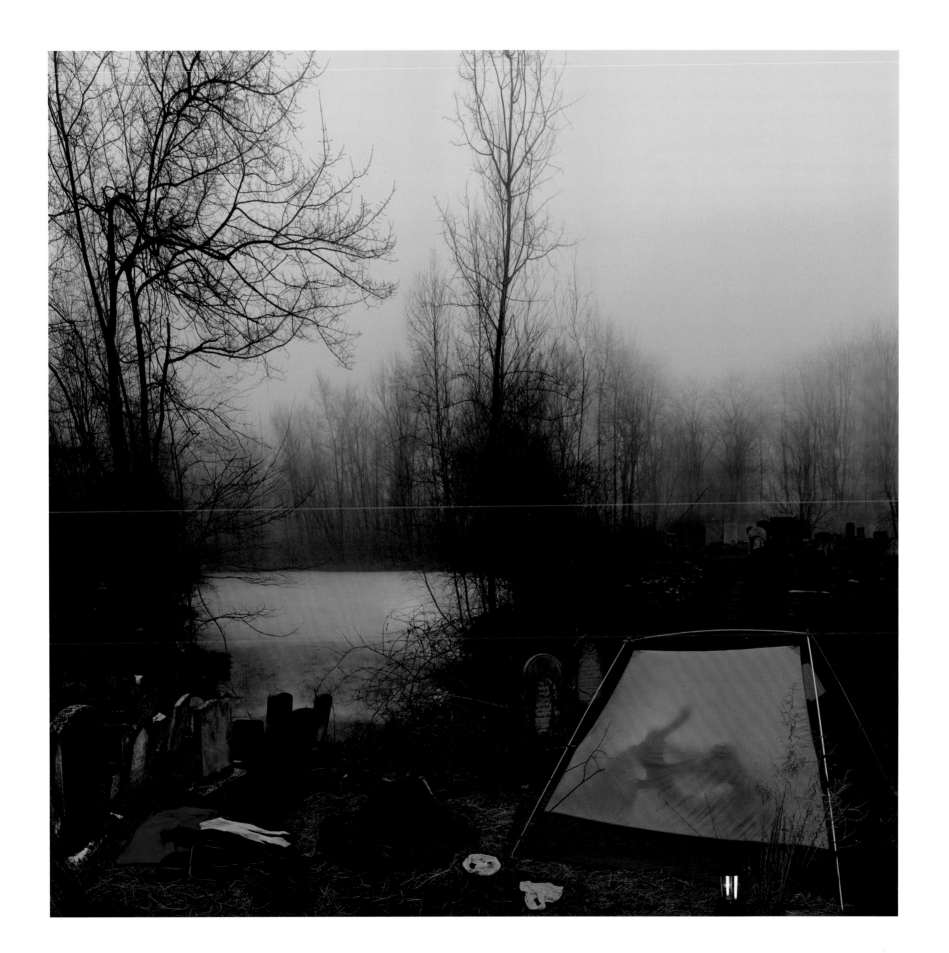

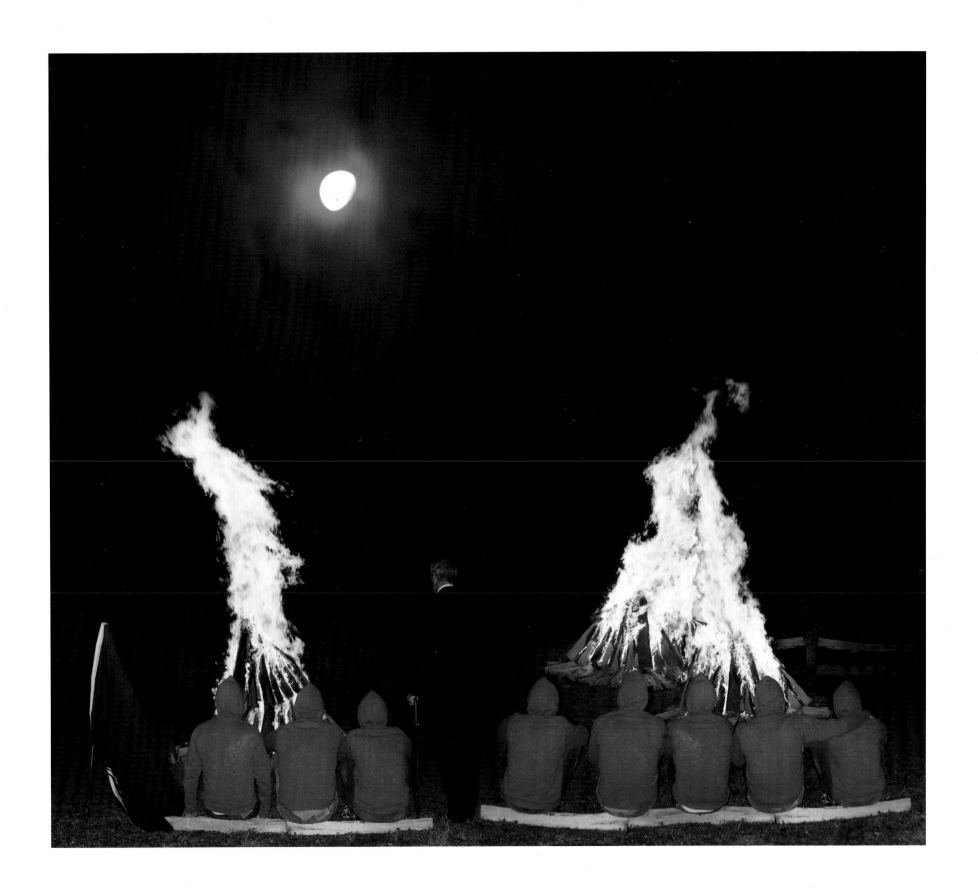

Plate 20
Still Life with Pig, 2005
Chromogenic print, mounted on aluminum and laminated
40 x 60 inches
North Carolina Museum of Art,
gift of Allen G. Thomas Jr., 2006.19

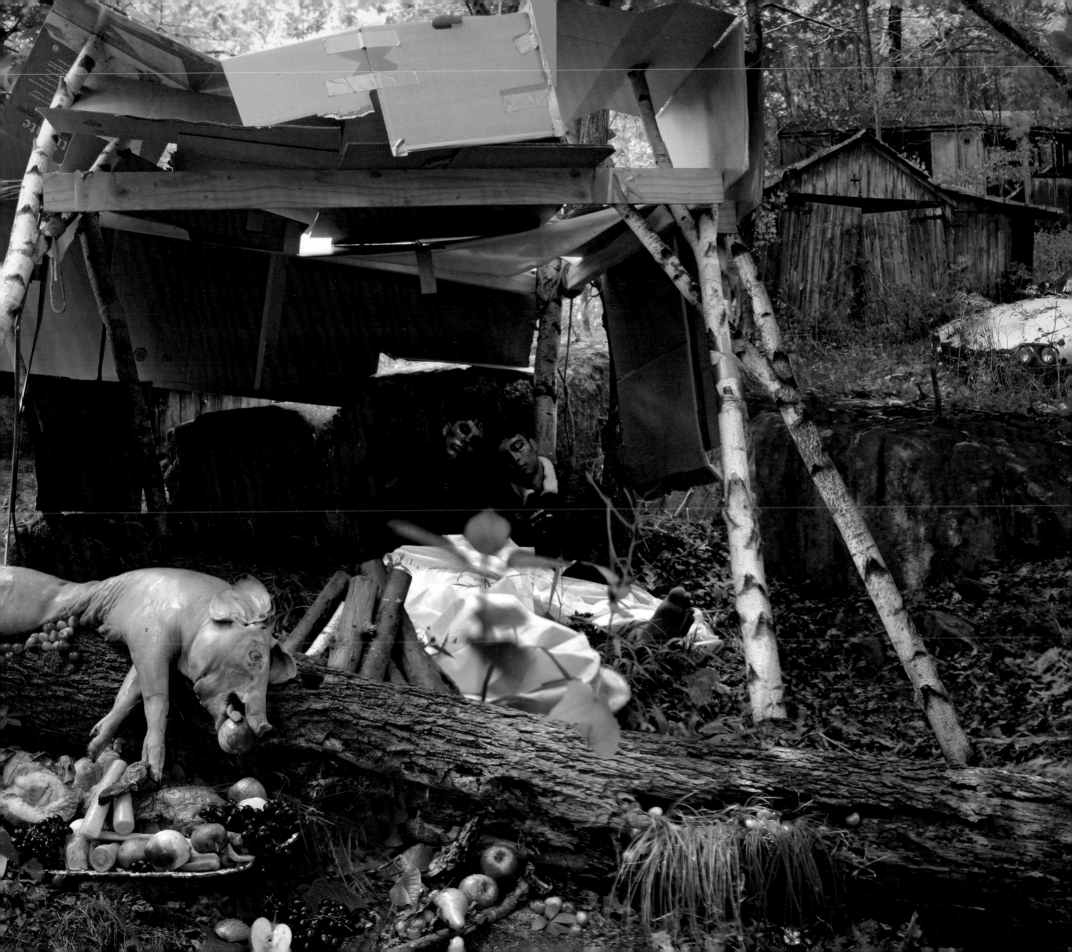

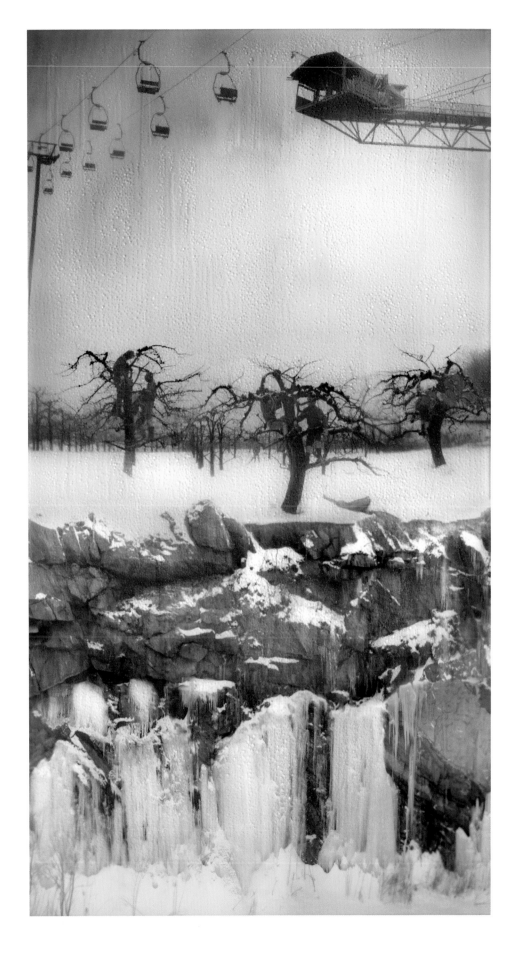

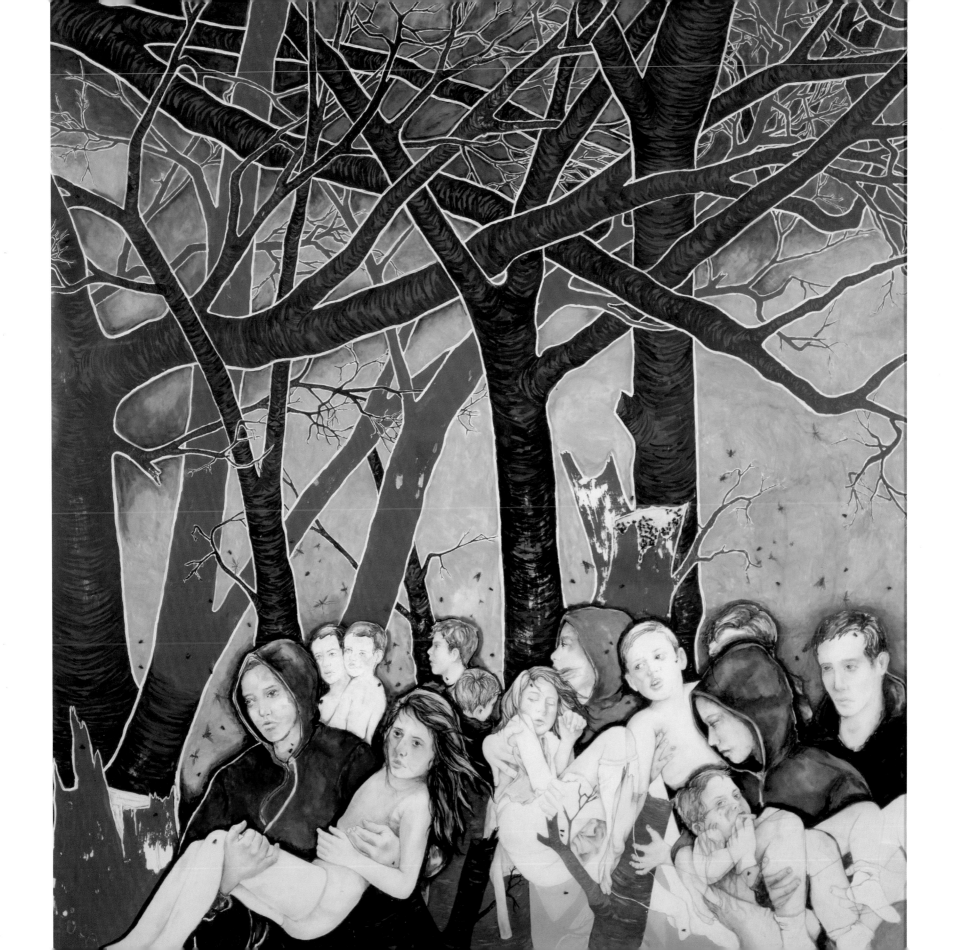

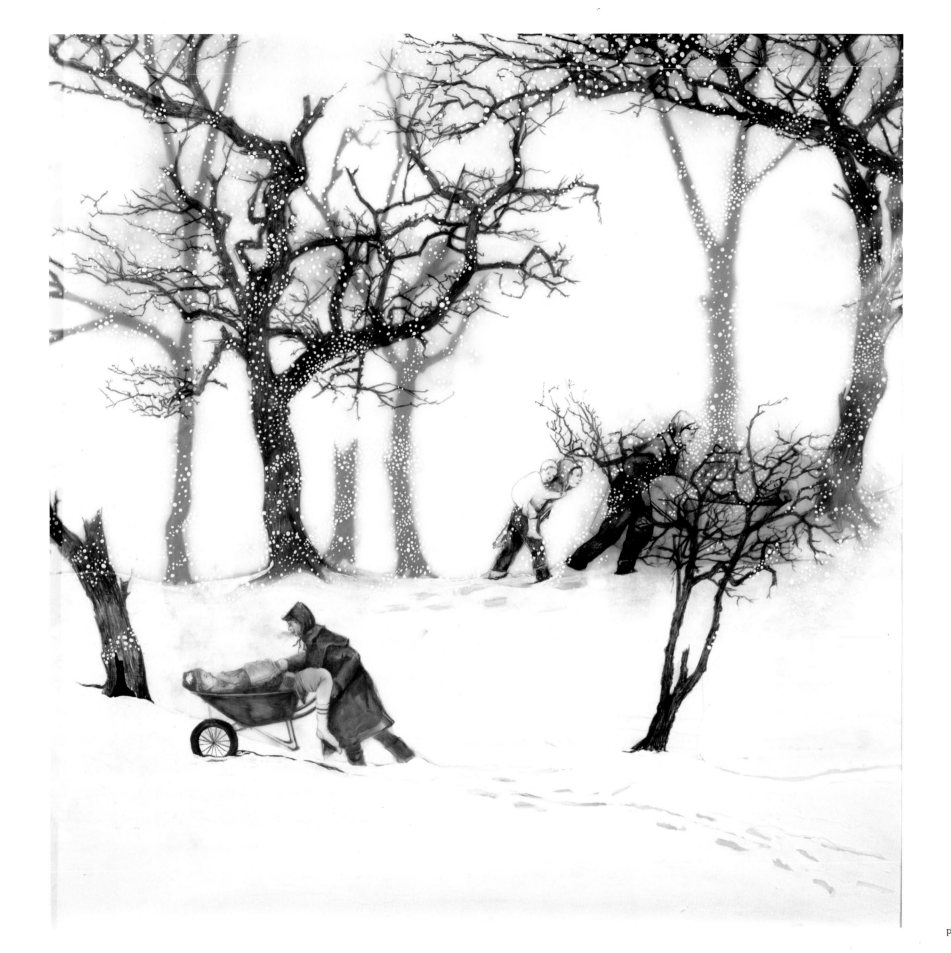

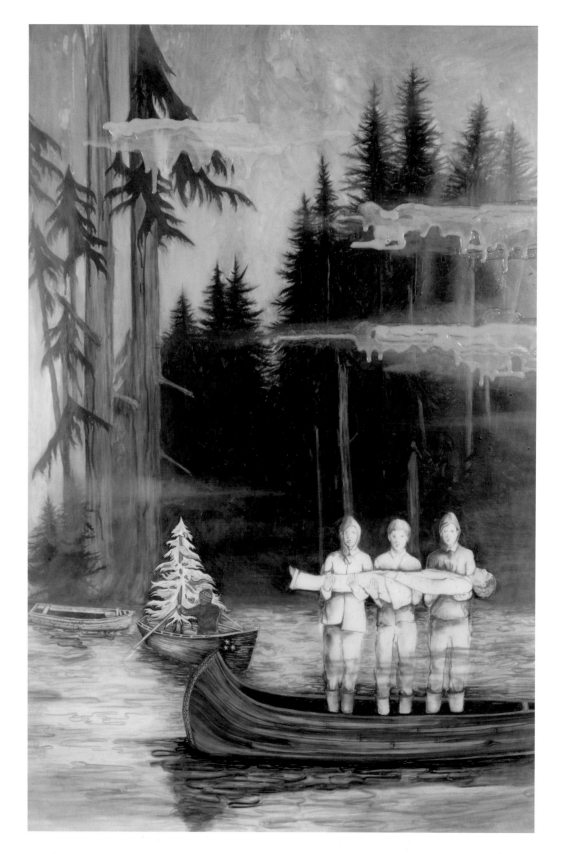

Plate 24
Dirge, 2005
Graphite, ink, and acrylic on Mylar
53 x 36 inches
Collection of Mario J. Palumbo Jr. and
Stefan Gargiulo

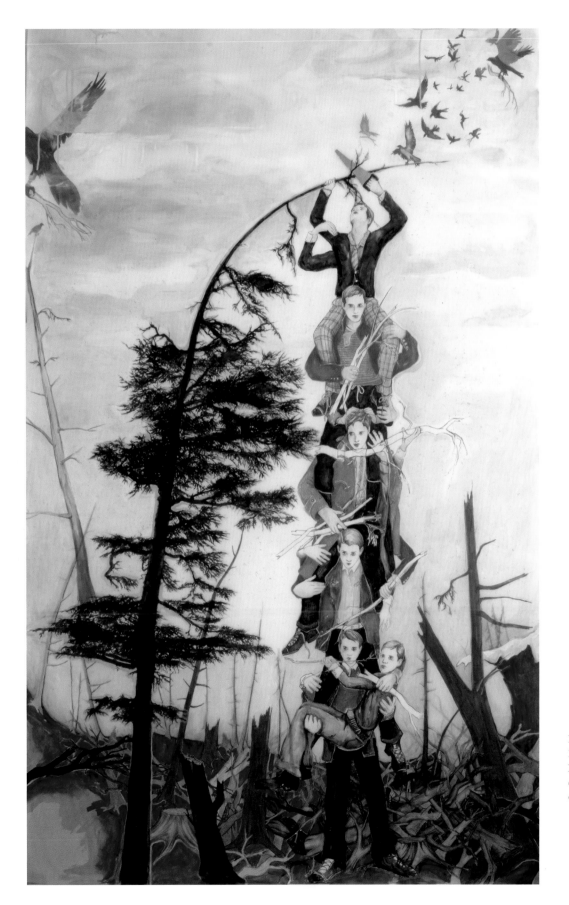

Plate 25
Disassembly, 2006
Mixed media on Mylar
69 1/4 x 41 1/2 inches
Collection of Allen G. Thomas Jr., Wilson, NC

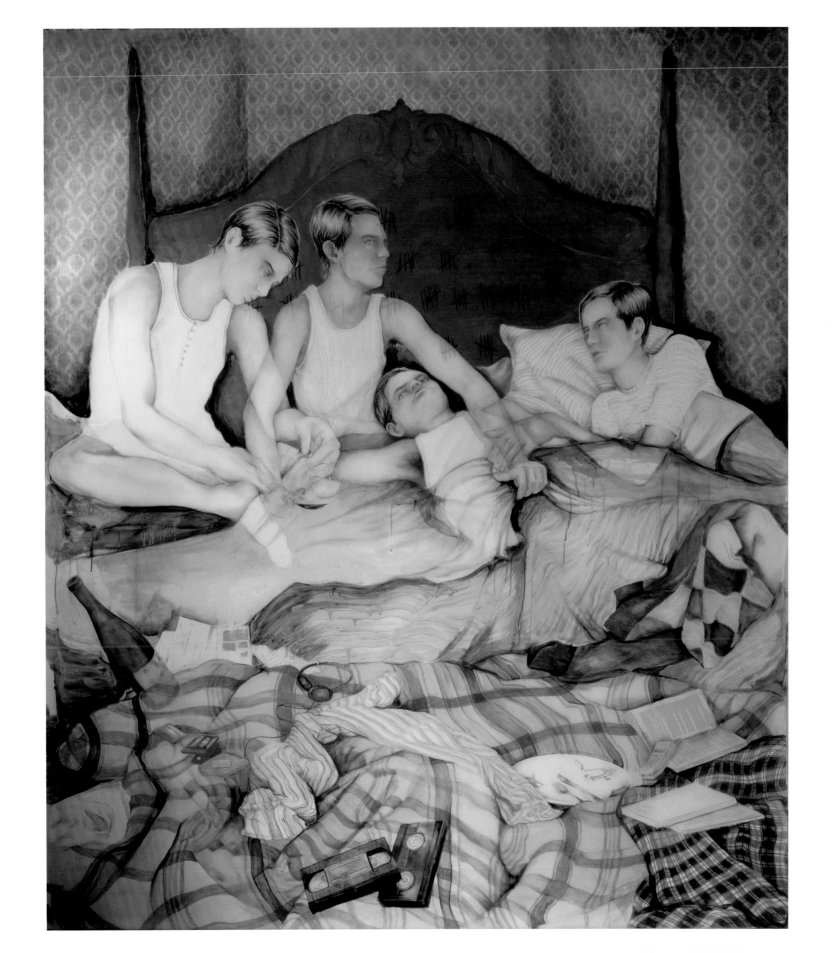

Plate 28
Still Waters, 2007
Chromogenic print
40 x 49 inches
Collection of R. Glen Medders

Plate 29
Search Party, 2007
Acrylic and mixed media on Mylar, mounted on wood
96 x 146 inches
Courtesy of 21c Museum and Collection of
Laura Lee Brown and Steve Wilson,
Louisville, KY

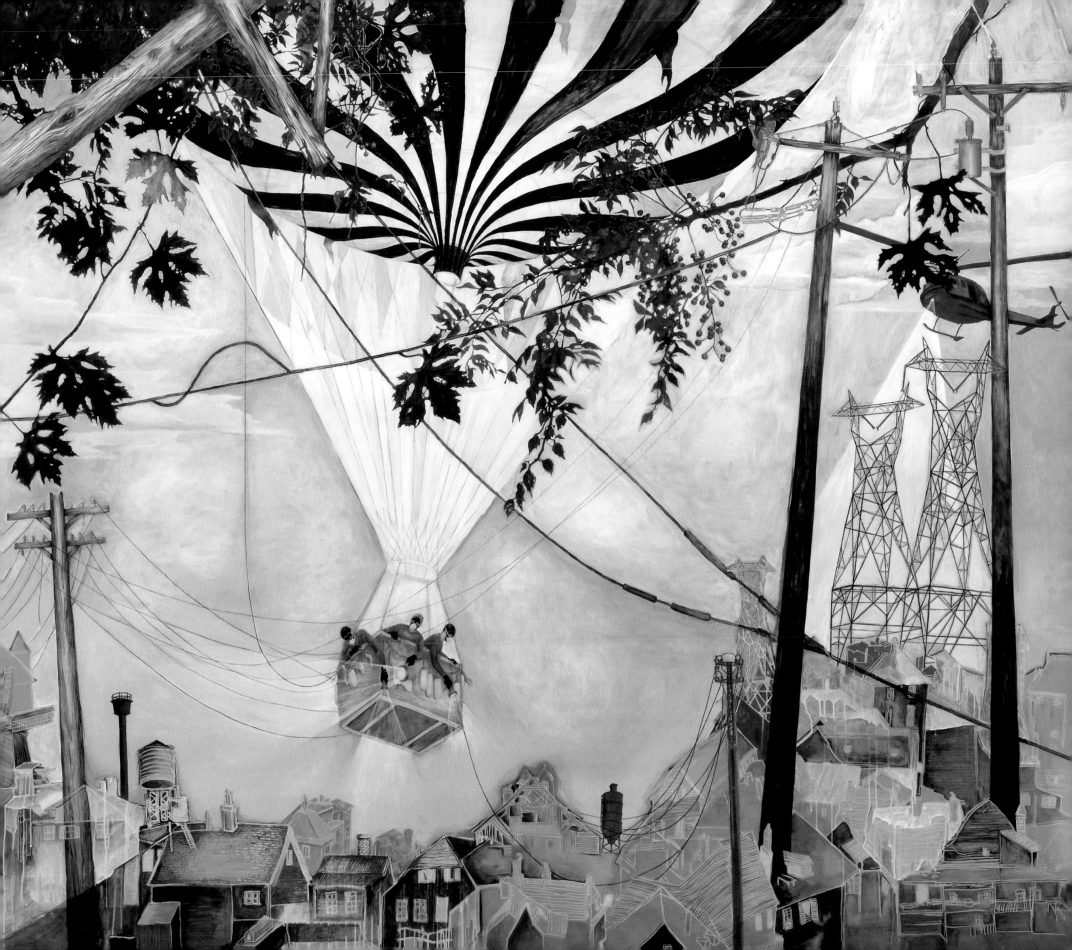

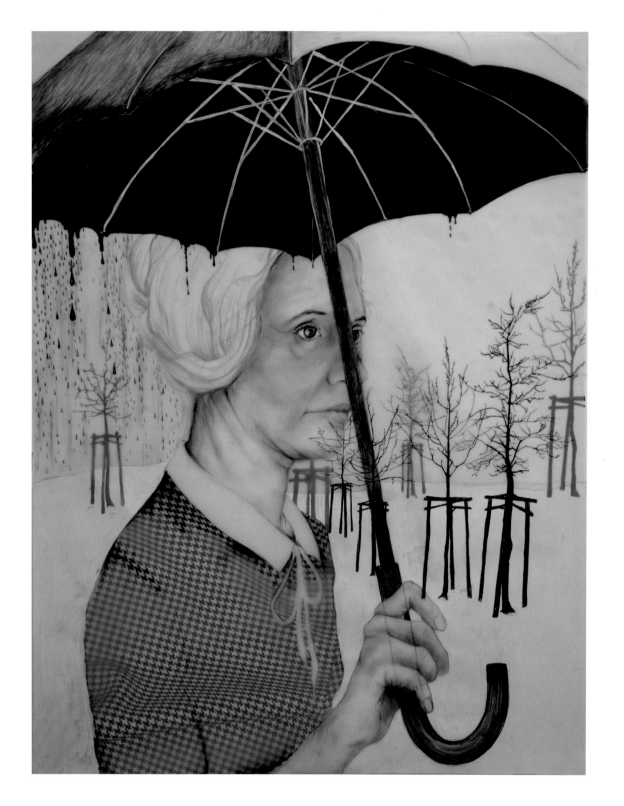

Plate 30
Umbrella, 2007
Mixed media on Mylar
31 x 24 inches
Courtesy of Friedman Benda, New York, and the Artist

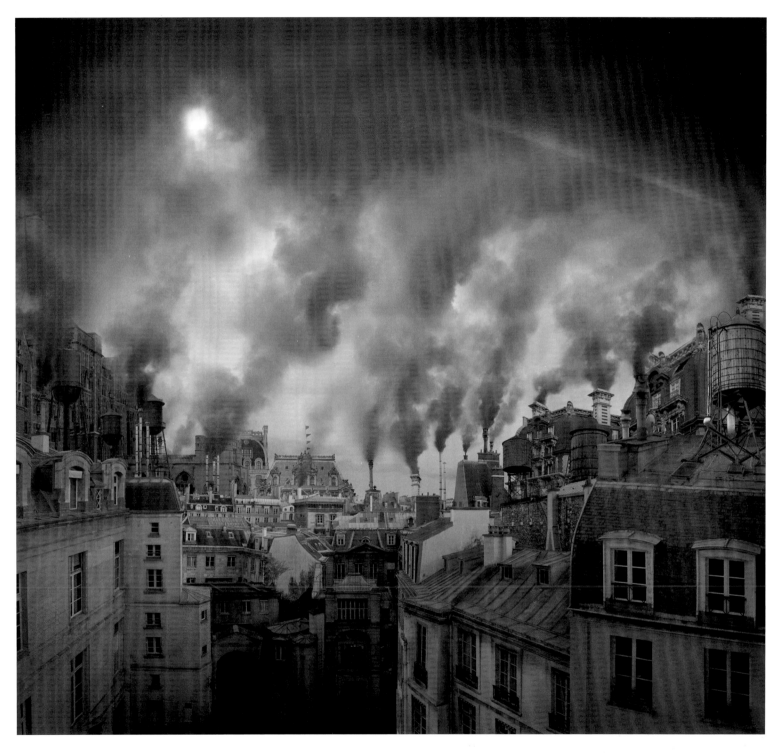

Plate 31
Smoke Stack, 2007
Chromogenic print, mounted on aluminum
and laminated with Plexiglas
55 x 60 inches
Collection of Allen G. Thomas Jr., Wilson, NC

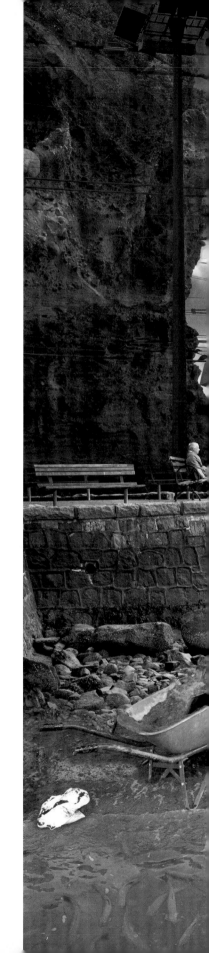

Plate 32
Low Tide, 2007
Chromogenic print, mounted on aluminum and laminated with Plexiglas
60 x 85 inches
Telfair Museum of Art, purchased with funds provided by the Jack W. Lindsay Endowment Fund, 2010.30

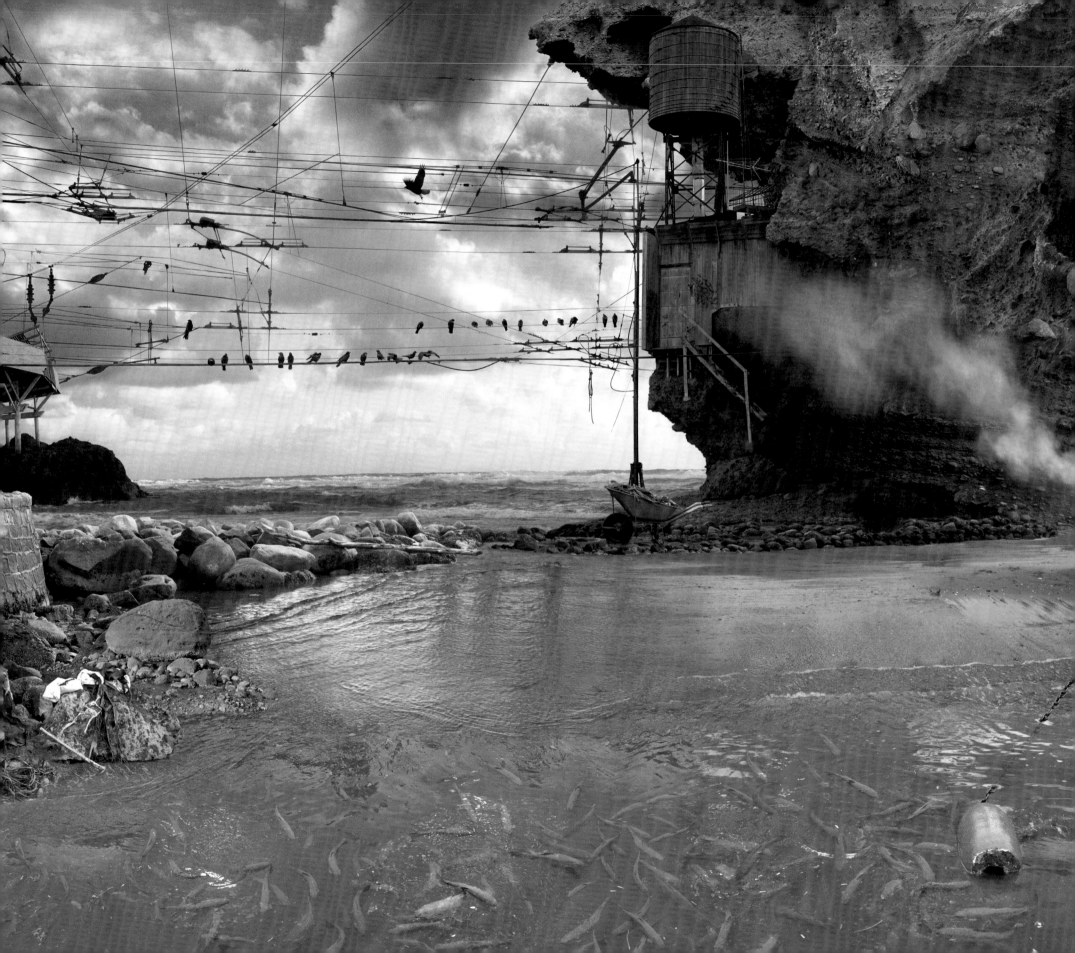

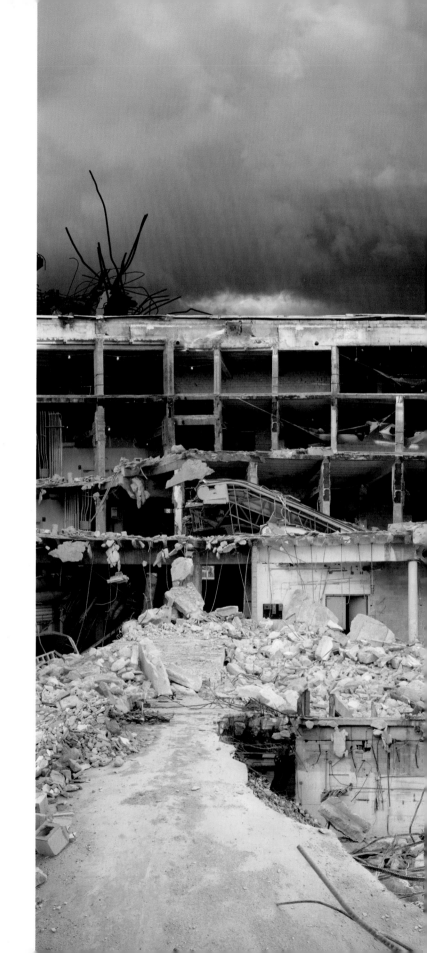

Plate 33
Deconstruction, 2007
Chromogenic print, mounted on aluminum and laminated with Plexiglas
72 x 117 1/2 inches
North Carolina Museum of Art, Gift of Allen G. Thomas Jr. in memory of Carolyn Thomas Marley, 2009.13

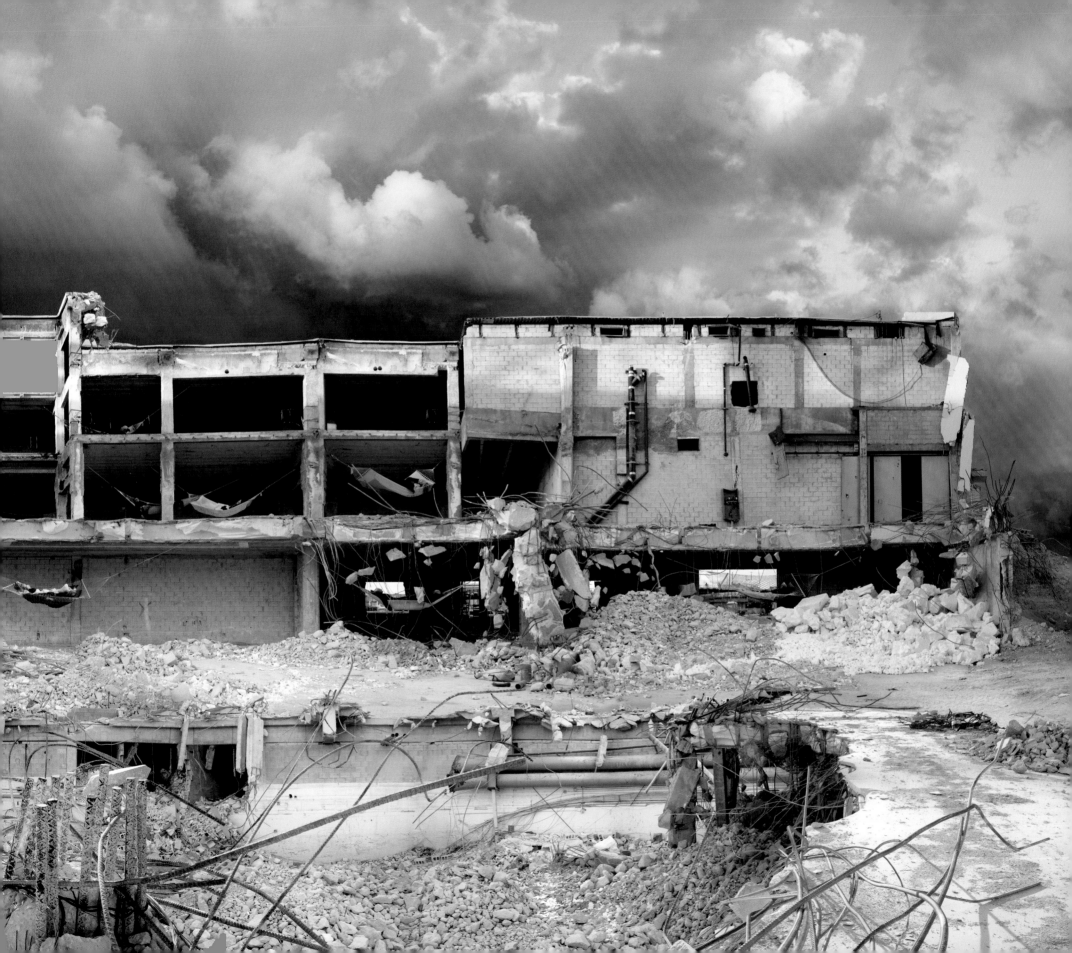

Plate 34
The Flood, 2008
Graphite and acrylic on Mylar
41 1/2 x 78 1/4 inches
Collection of Dr. W. Kent Davis, Raleigh, NC

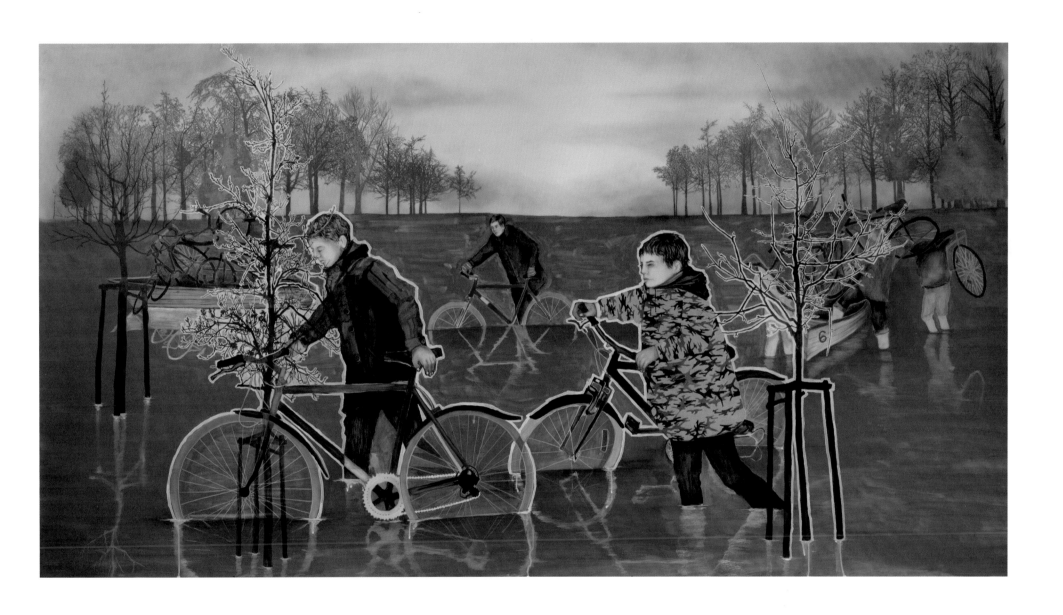

Plate 35
Guardian, 2008
Chromogenic print
39 3/4 x 84 5/8 inches
Telfair Museum of Art, purchased with funds provided by
the William Jay Society, 2010.29

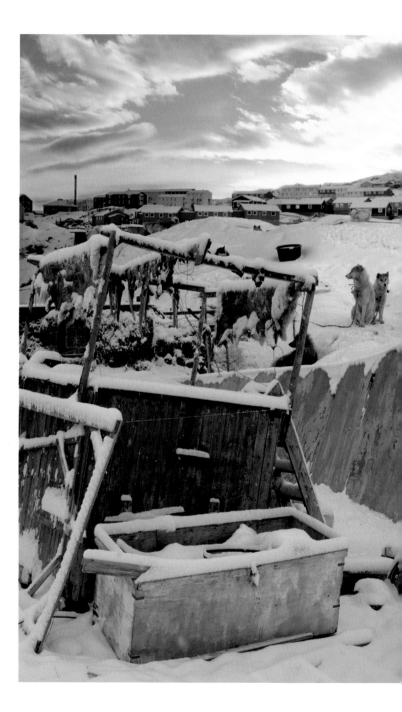

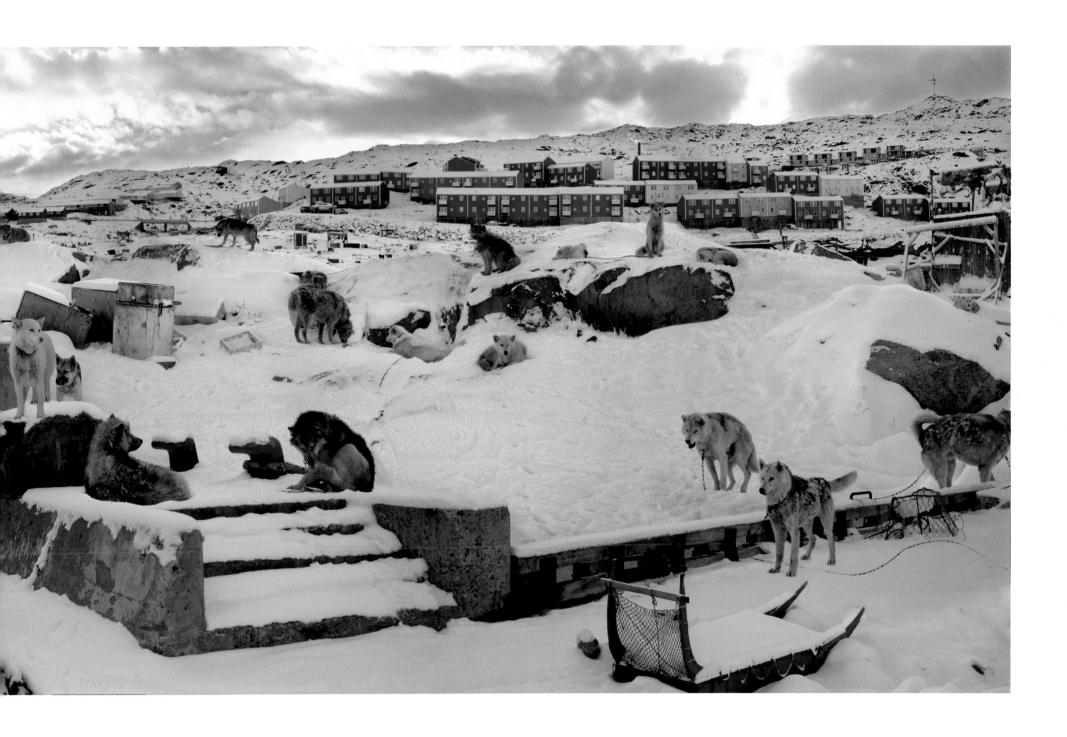

Plate 36
Related 1a, 2008
Graphite on Mylar
17 x 13 inches
Collection of Allen G. Thomas Jr., Wilson, NC

Plate 37
Related 1b, 2008
Black-and-white digital print
25 1/4 x 19 1/2 inches
Collection of Allen G. Thomas Jr., Wilson, NC

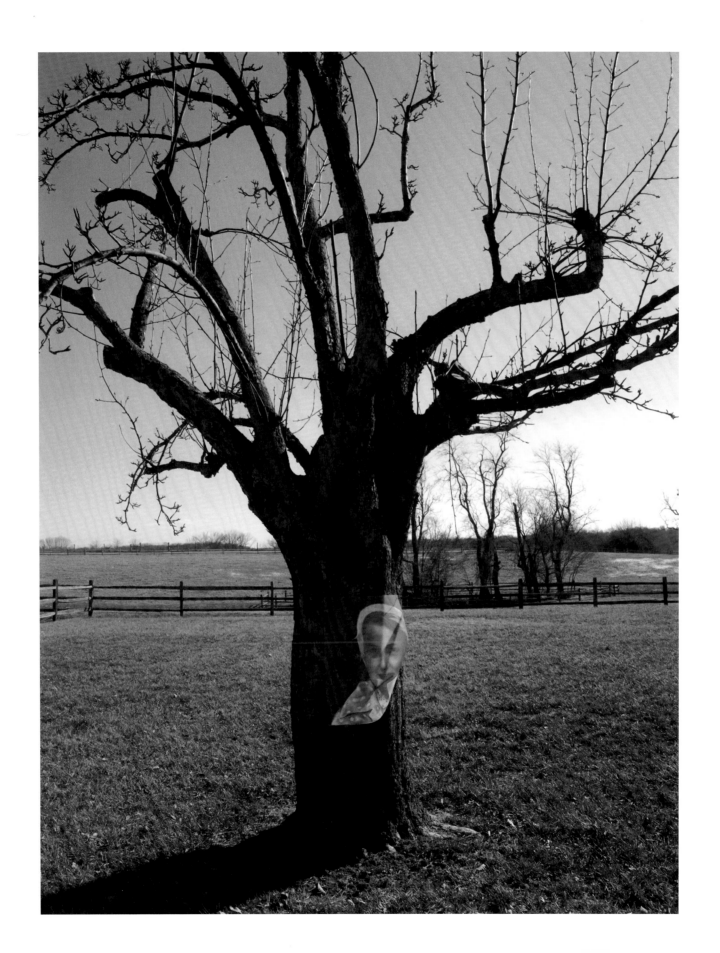

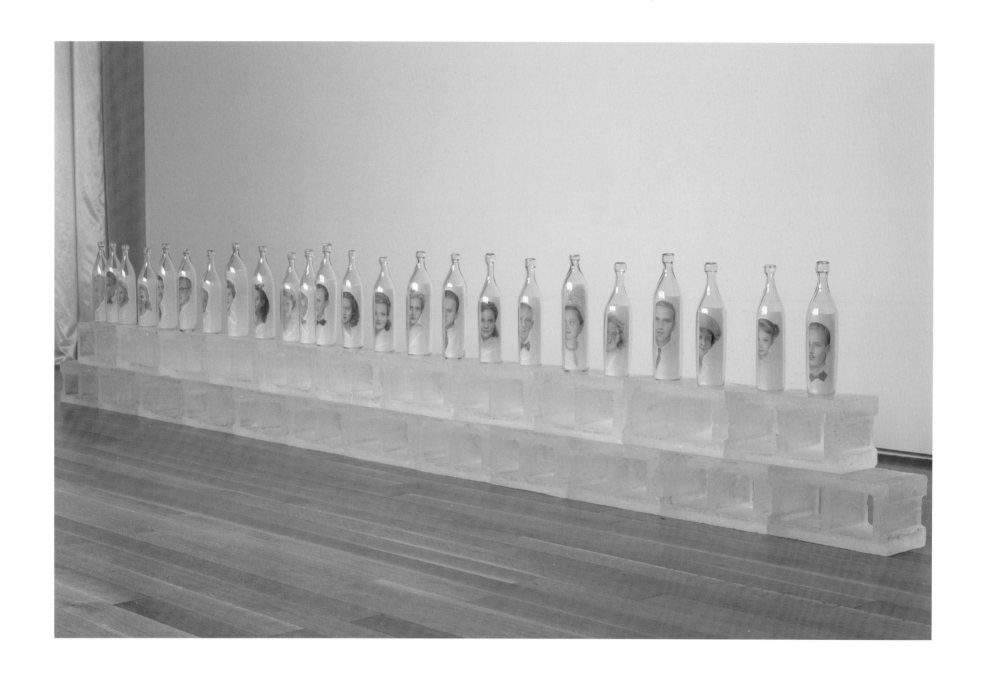

Plate 39
Sea Wall, 2008
24 cast lead crystal blocks; 24 hand-polished, hand-blown glass bottles,
each containing a graphite-on-Mylar drawing
Dimensions variable
Courtesy of the Artist and Postmasters Gallery, New York, NY

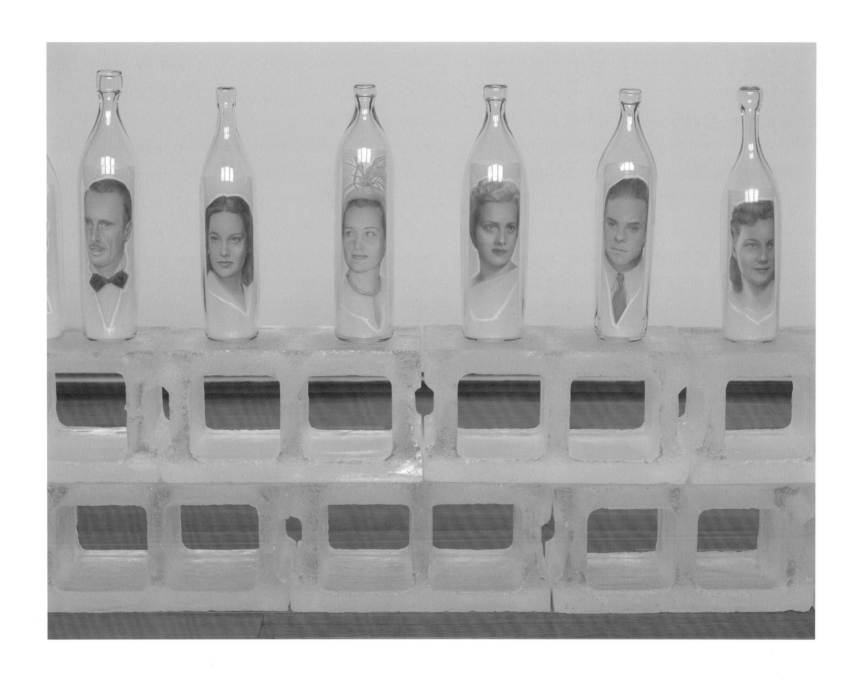

Plate 39
Sea Wall (detail), 2008

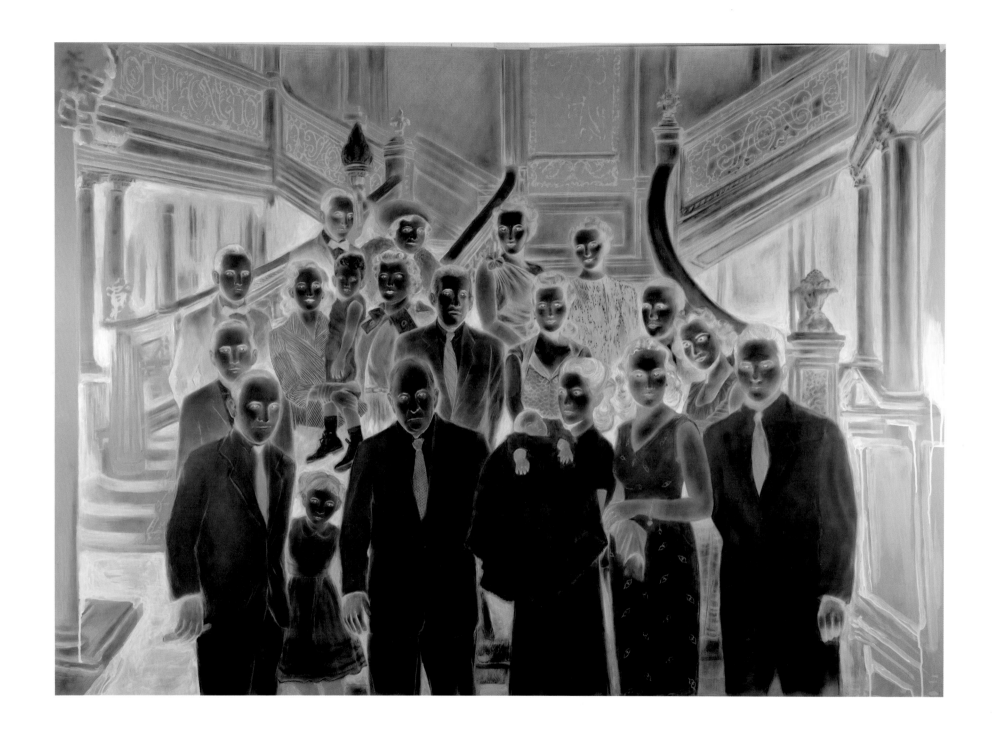

Plate 40
Related 26a and **26b,** 2008
Graphite and acrylic on Mylar (left); Chromogenic print (right)
Diptych: 42 x 58 inches each
Private Collection

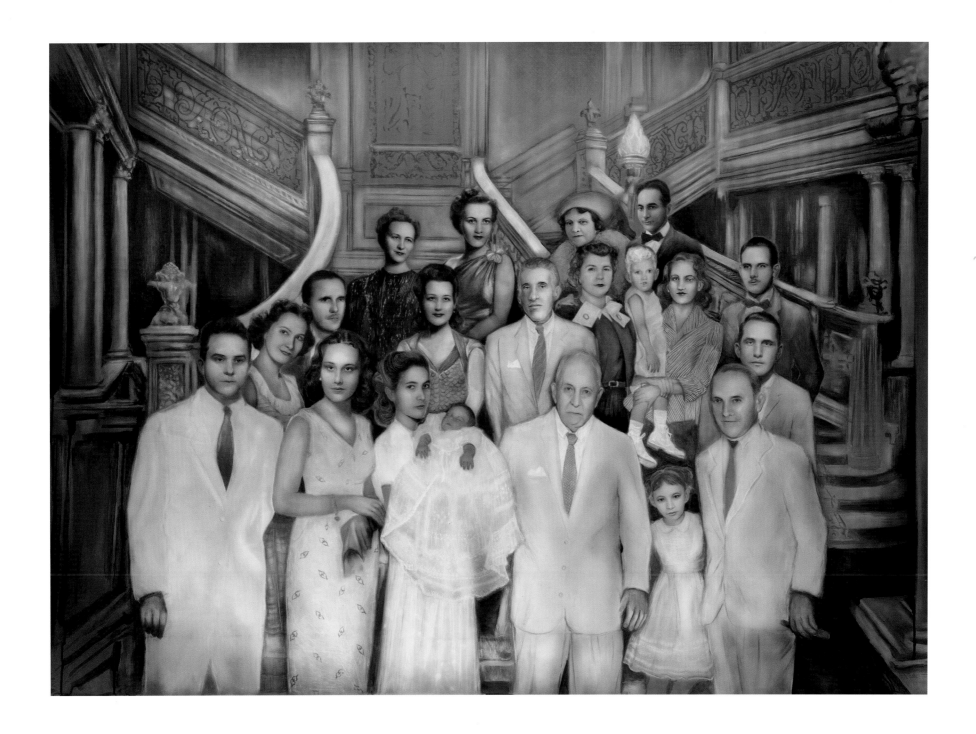

Plate 41
Family Geometry, 2008
Ink and acrylic on canvas
50 x 66 1/2 inches
Courtesy of the Artist and
Postmasters Gallery, New York, NY

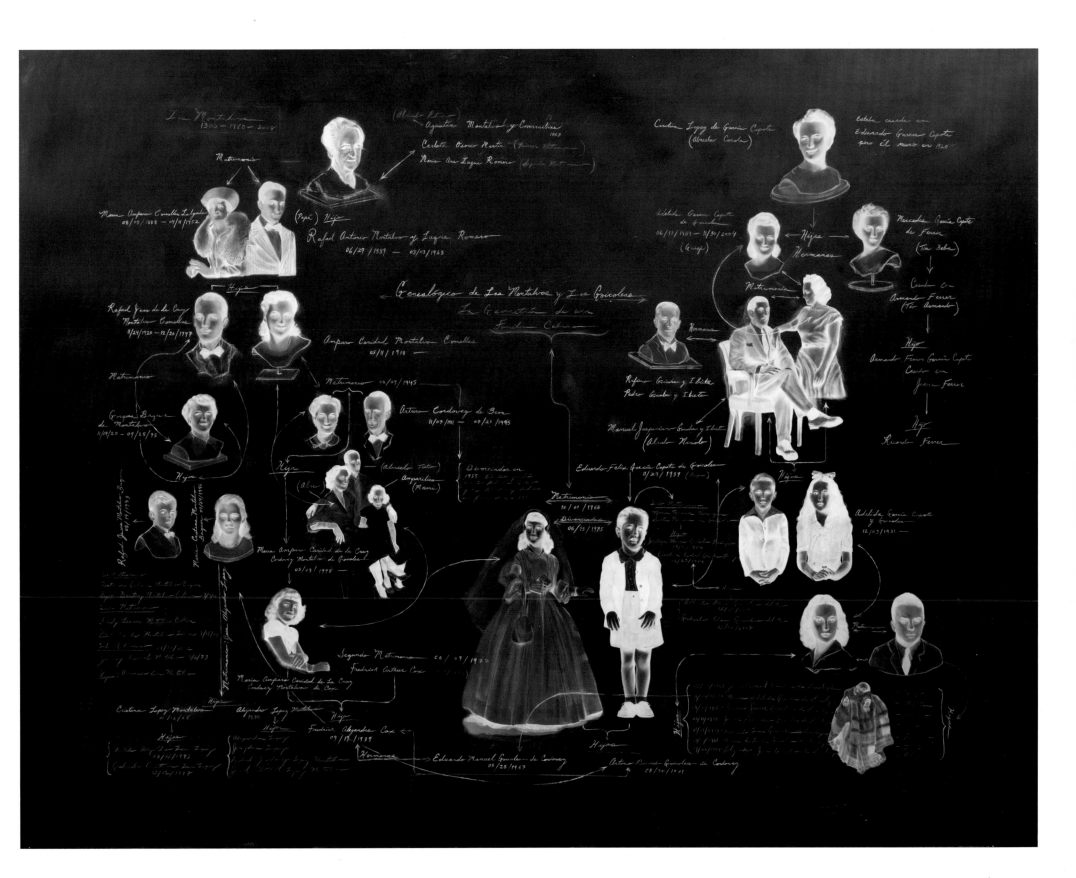

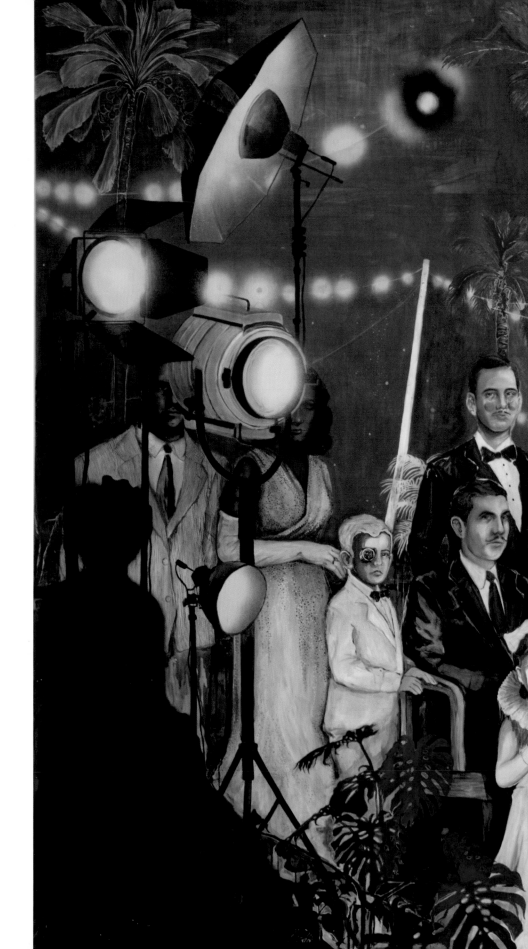

Plate 42
Night Sitting, 2009
Acrylic, graphite, and spray-paint on Mylar
Triptych: 81 x 124 inches overall; each panel 81 x 42 inches
Courtesy of 21c Museum and Collection of
Laura Lee Brown and Steve Wilson,
Louisville, KY

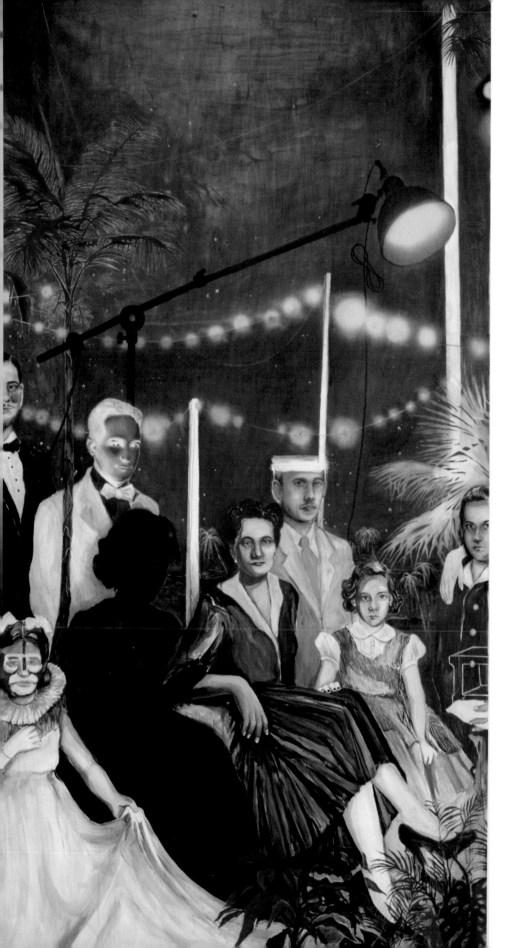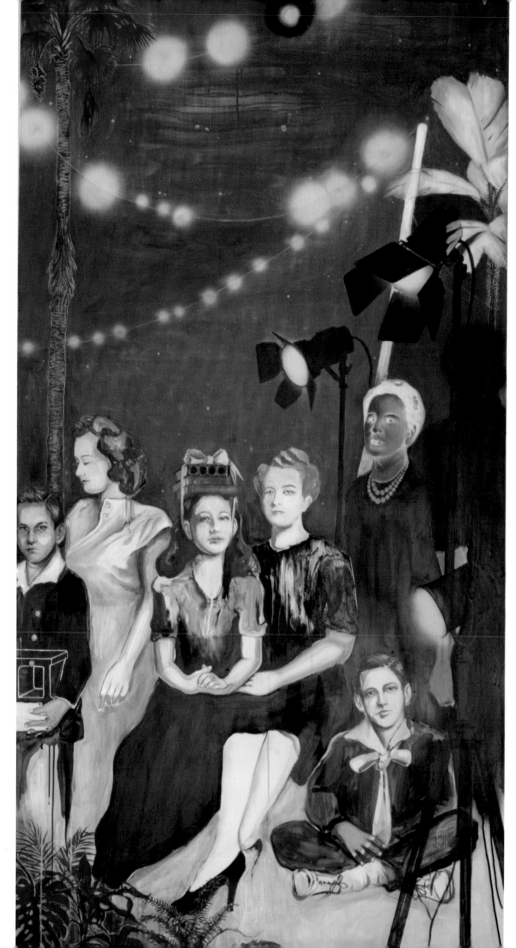

Plate 44
For All the Days, 2010
Acrylic on Mylar
35 x 35 inches
Collection of Mario J. Palumbo Jr. and Stefan Gargiulo

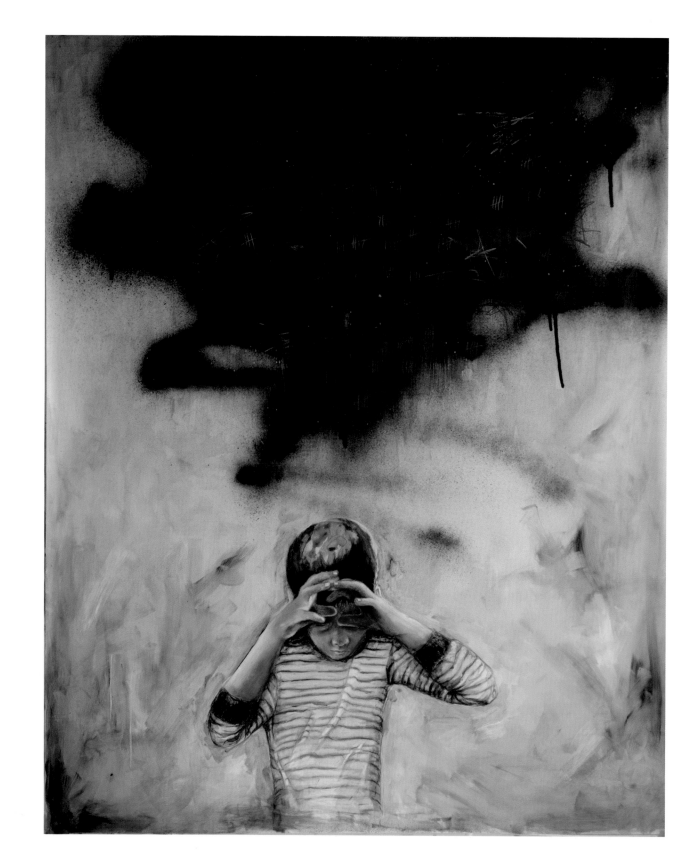

Plate 45
Piñata, 2010
Chromogenic print
30 x 30 inches
Courtesy of Friedman Benda,
New York, and the Artist

Plate 46
Siamese Twins, 2010
Chromogenic print
40 x 40 inches
Courtesy of Friedman Benda,
New York, and the Artist

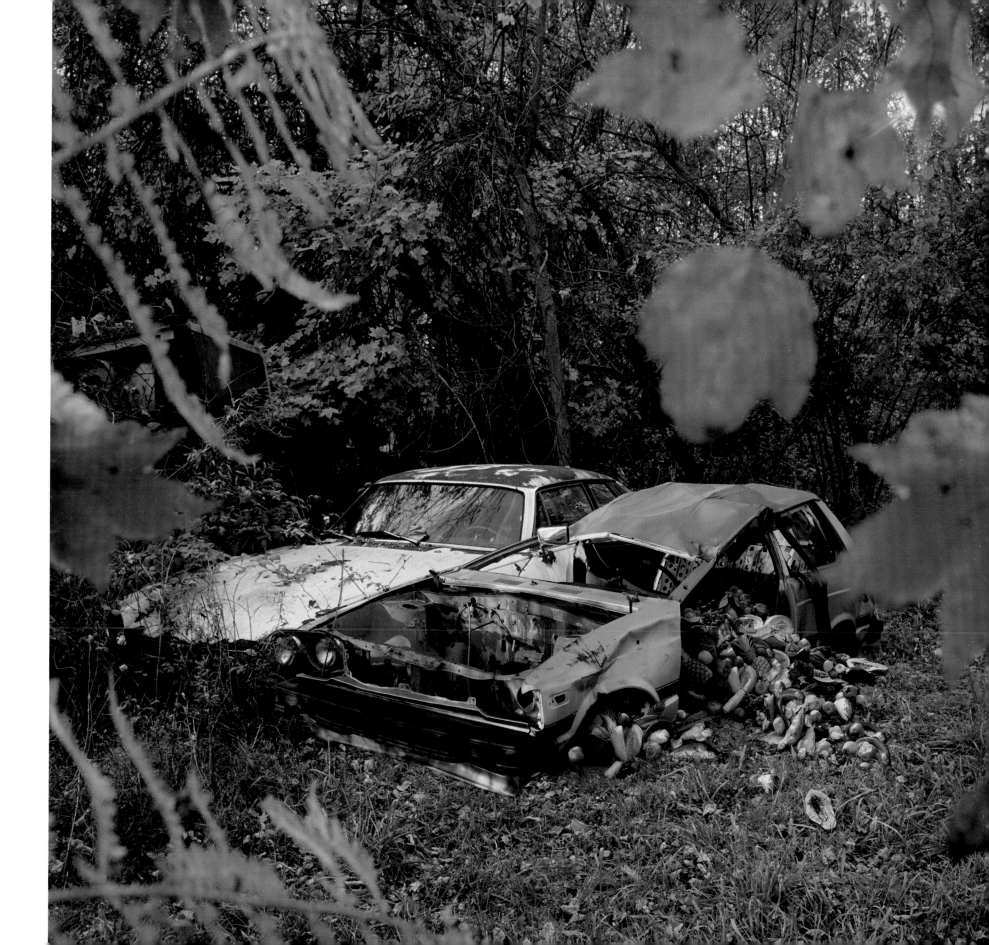

Plate 47
Island, 2010
Chromogenic print
40 x 40 inches
Courtesy of Friedman Benda,
New York, and the Artist

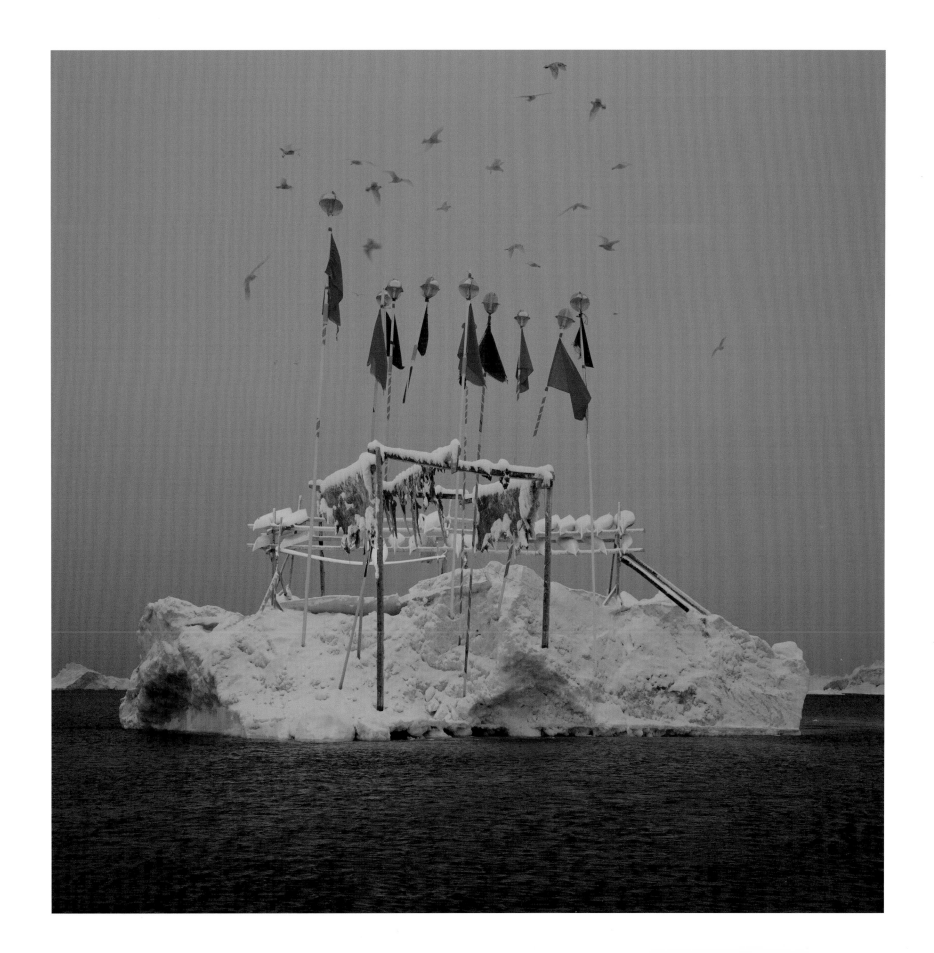

Plate 48
Territorial, 2010
Chromogenic print
40 x 40 inches
Courtesy of Friedman Benda,
New York, and the Artist

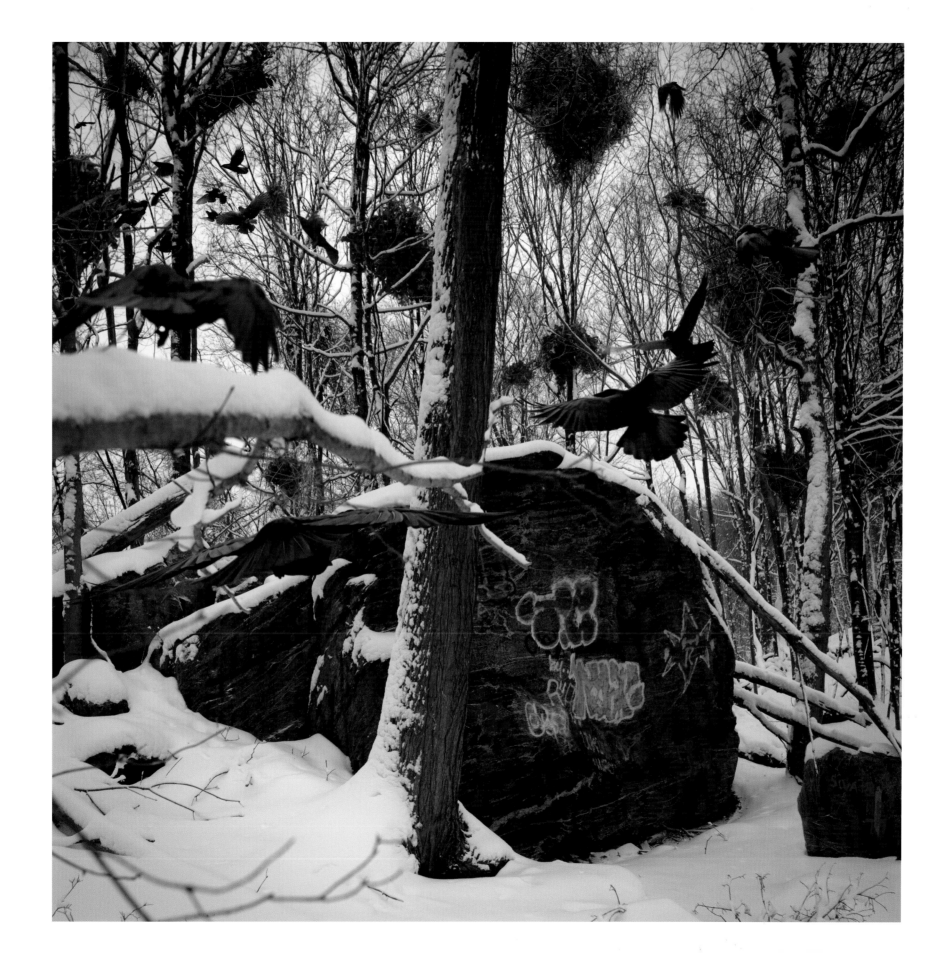

Plate 49
Black House, 2010
Chromogenic print
30 x 30 inches
Courtesy of Friedman Benda,
New York, and the Artist

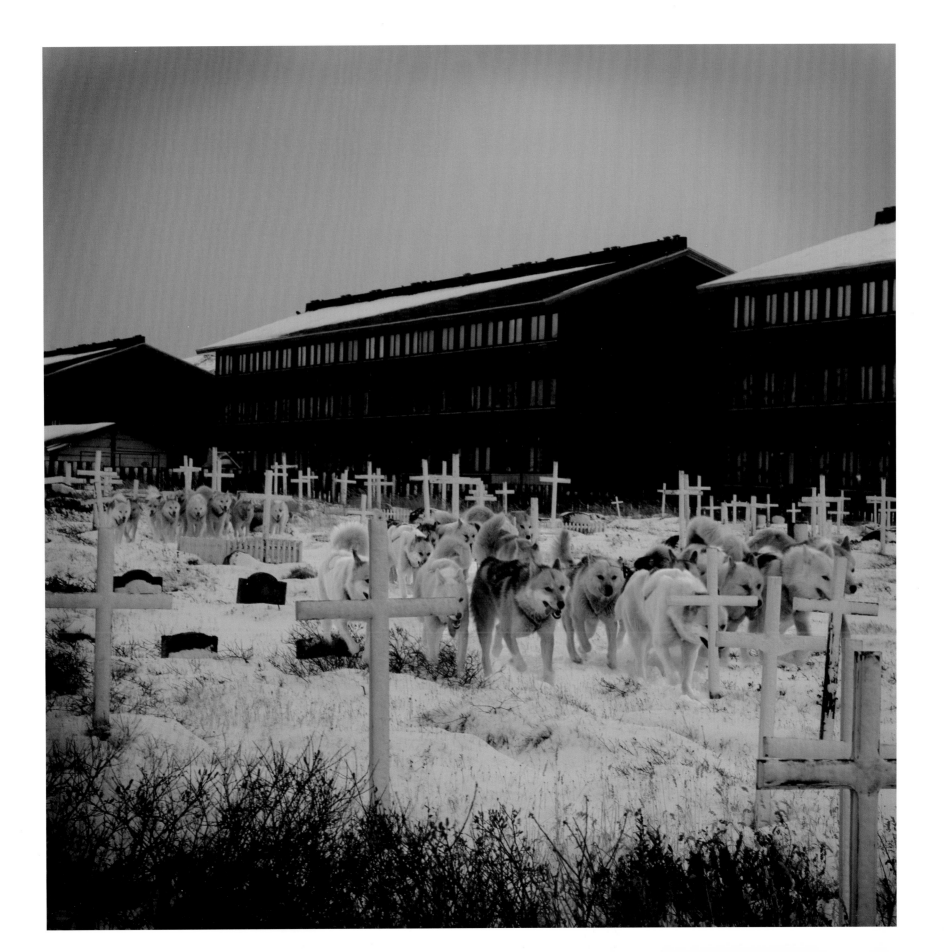

Illustrated Appendix

Alter Ego: A Decade of Work by Anthony Goicolea
Catalogue Checklist

Items marked with an asterisk (*) are on view only at Telfair Museums and 21c Museum. All other items are on view at all three exhibition locations.

Anthony Goicolea American, born 1971

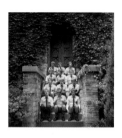

1. *Class Picture*, 1999
Chromogenic print
42 x 40 inches
Collection of Fred and Ampy Cox

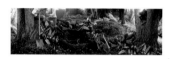

5. *Grave Diggers**, 2001
Chromogenic print
30 x 102 inches
Courtesy of the Artist and Postmasters Gallery,
New York, NY

2. *Ash Wednesday*, 2001
Chromogenic print, mounted on Sintra and
laminated
40 x 89 inches
Courtesy of 21c Museum and Collection of
Laura Lee Brown and Steve Wilson,
Louisville, KY

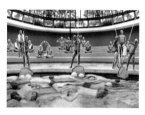

6. *Pool Pushers*, 2001
Chromogenic print
71 x 100 inches
Collection of Dr. Carlos Garcia-Velez, Raleigh, NC

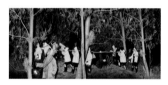

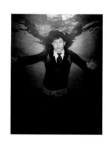

7. *Under I*, 2001
Chromogenic print
20 x 16 inches
Courtesy of 21c Museum and Collection of
Laura Lee Brown and Steve Wilson,
Louisville, KY

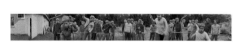

3. *Warriors*, 2001
Chromogenic print, mounted on Sintra board
30 x 276 inches
Courtesy of 21c Museum and Collection of Laura
Lee Brown and Steve Wilson,
Louisville, KY

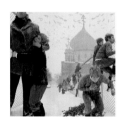

4. *Blizzard*, 2001
Chromogenic print
40 x 42 inches
Collection of Allen G. Thomas Jr., Wilson, NC

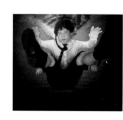

8. *Under II*, 2001
Chromogenic print
20 x 24 inches
Courtesy of 21c Museum and Collection of
Laura Lee Brown and Steve Wilson,
Louisville, KY

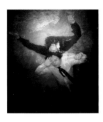

9. *Under III*, 2001
Chromogenic print
20 x 18 inches
Courtesy of 21c Museum and Collection of
Laura Lee Brown and Steve Wilson,
Louisville, KY

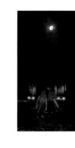

14. *Midnight Kiss*, 2004
Chromogenic print, mounted on aluminum
and laminated with Plexiglas
76 3/16 x 40 3/16 inches
Collection of Allen G. Thomas Jr., Wilson, NC

10. *Under V*, 2001
Chromogenic print
20 x 15 inches
Courtesy of 21c Museum and Collection of
Laura Lee Brown and Steve Wilson,
Louisville, KY

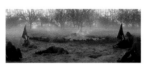

15. *Morning Sleep*, 2004
Chromogenic print, mounted on aluminum
and laminated
40 x 105 inches
North Carolina Museum of Art, purchased
with funds from June Ficklen, 2007.3

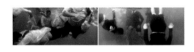

11. *Amphibians*, 2002
Single-channel DVD
Courtesy of Postmasters Gallery,
New York, NY

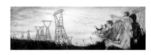

16. *Cat's Cradle*, 2004
Graphite, ink, and acrylic on Mylar
23 1/2 x 77 3/4 inches
Collection of Allen G. Thomas Jr., Wilson, NC

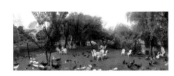

12. *Cherry Island**, 2002
Chromogenic print
27 x 71 inches
Collection of Mr. Edsel Williams

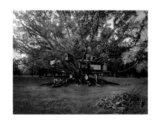

17. *Tree Dwellers*, 2004
Chromogenic print, laminated and mounted
on Sintra board
72 x 97 inches
Courtesy of Laura Lee Brown and Steve Wilson,
Louisville, KY, and Collection of the
International Contemporary Art Foundation

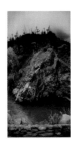

13. *Cliffside**, 2002
Chromogenic print
49 x 25 inches
Collection of Jennifer Dalton and
Wellington Fan

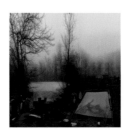

18. *Lake**, 2004
Chromogenic print
72 x 72 inches
Courtesy of 21c Museum and Collection of
Laura Lee Brown and Steve Wilson,
Louisville, KY

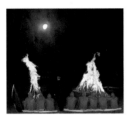

19. *Kidnap*, 2004-05
 Single-channel DVD
 Courtesy of Postmasters Gallery,
 New York, NY

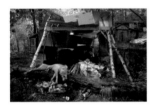

20. *Still Life with Pig*, 2005
 Chromogenic print, mounted on aluminum
 and laminated
 40 x 60 inches
 North Carolina Museum of Art,
 gift of Allen G. Thomas Jr., 2006.19

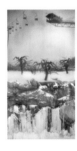

21. *Orchard**, 2005
 Chromogenic print, mounted on aluminum
 and laminated
 65 x 35 inches
 Collection of Philip Aarons and Shelley Fox
 Aarons, New York, NY

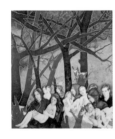

22. *Fleeing*, 2005
 Acrylic, ink, graphite, and collage on Mylar
 85 x 75 inches
 Hort Family Collection

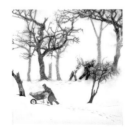

23. *Defectors*, 2005
 Graphite, ink, and acrylic on Mylar
 24 x 24 inches
 Collection of Lesley Lana-Heimlich and Philip
 Heimlich (Courtesy Collector Circle, Inc.)

24. *Dirge*, 2005
 Graphite, ink, and acrylic on Mylar
 53 x 36 inches
 Collection of Mario J. Palumbo Jr.
 and Stefan Gargiulo

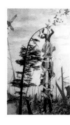

25. *Disassembly*, 2006
 Mixed media on Mylar
 69 1/4 x 41 1/2 inches
 Collection of Allen G. Thomas Jr., Wilson, NC

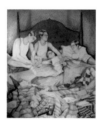

26. *Bed Ridden**, 2006
 Graphite and ink on Mylar
 96 x 78 inches
 Courtesy of 21c Museum and Collection of
 Laura Lee Brown and Steve Wilson,
 Louisville, KY

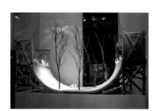

27. *Ramp*, 2006
 Reclaimed wood, silicone, trees, and birds
 120 x 197 x 67 inches
 Courtesy of 21c Museum and Collection of
 Laura Lee Brown and Steve Wilson,
 Louisville, KY

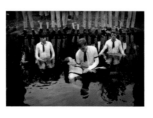

28. *Still Waters,* 2007
 Chromogenic print
 40 x 49 inches
 Collection of R. Glen Medders

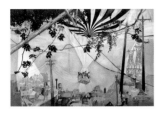

29. *Search Party*, 2007
Acrylic and mixed media on Mylar,
mounted on wood
96 x 146 inches
Courtesy of 21c Museum and Collection of
Laura Lee Brown and Steve Wilson,
Louisville, KY

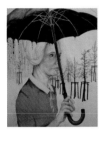

30. *Umbrella*, 2007
Mixed media on Mylar
31 x 24 inches
Courtesy of Friedman Benda, New York,
and the Artist

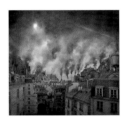

31. *Smoke Stack*, 2007
Chromogenic print, mounted on aluminum and
laminated with Plexiglas
55 x 60 inches
Collection of Allen G. Thomas Jr., Wilson, NC

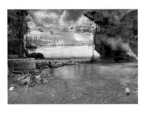

32. *Low Tide*, 2007
Chromogenic print, mounted on aluminum and
laminated with Plexiglas
60 x 85 inches
Telfair Museum of Art, purchased with funds pro-
vided by the Jack W. Lindsay Endowment Fund,
2010.30

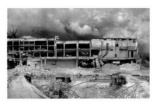

33. *Deconstruction*, 2007
Chromogenic print, mounted on aluminum
and laminated with Plexiglas
72 x 117 1/2 inches
North Carolina Museum of Art, gift of
Allen G. Thomas Jr. in memory of
Carolyn Thomas Marley, 2009.13

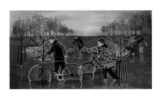

34. *The Flood*, 2008
Graphite and acrylic on Mylar
41 1/2 x 78 1/4 inches
Collection of Dr. W. Kent Davis, Raleigh, NC

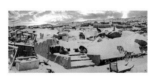

35. *Guardian*, 2008
Chromogenic print
39 3/4 x 84 5/8 inches
Telfair Museum of Art, purchased with funds
provided by the William Jay Society, 2010.29

36. *Related 1a*, 2008
Graphite on Mylar
17 x 13 inches
Collection of Allen G. Thomas Jr., Wilson, NC

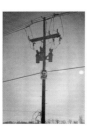

37. *Related 1b*, 2008
Black-and-white digital print
25 1/4 x 19 1/2 inches
Collection of Allen G. Thomas Jr., Wilson, NC

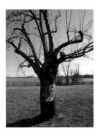

38. *Related 5b*, 2008
Black-and-white digital print
26 x 20 inches
Courtesy of 21c Museum and Collection of
Laura Lee Brown and Steve Wilson,
Louisville, KY

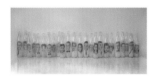

39. *Sea Wall*, 2008
24 cast lead crystal blocks;
24 hand-polished, hand-blown glass bottles,
each containing a graphite-on-Mylar drawing
Dimensions variable
Courtesy of the Artist and Postmasters
Gallery, New York, NY

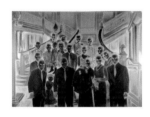
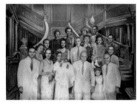

40. *Related 26a* and *26b*, 2008
Graphite and acrylic on Mylar;
Chromogenic print
Diptych: 42 x 58 inches each
Private Collection

41. *Family Geometry*, 2008
Ink and acrylic on canvas
50 x 66 1/2 inches
Courtesy of the Artist and
Postmasters Gallery, New York, NY

42. *Night Sitting*, 2009
Acrylic, graphite, and spray-paint on Mylar
Triptych: 81 x 124 inches overall;
each panel 81 x 42 inches
Courtesy of 21c Museum and Collection of
Laura Lee Brown and Steve Wilson,
Louisville, KY

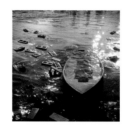

43. *Jettisoned*, 2009
Chromogenic print, mounted on aluminum
and laminated
40 x 40 inches
Collection of the artist and
Postmasters Gallery

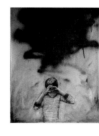

44. *For All the Days*, 2010
Acrylic on Mylar
35 x 35 inches
Collection of Mario J. Palumbo Jr.
and Stephan Gargiulo

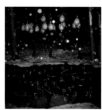

45. *Piñata*, 2010
Chromogenic print
30 x 30 inches
Courtesy of Friedman Benda, New York,
and the Artist

46. *Siamese Twins*, 2010
Chromogenic print
40 x 40 inches
Courtesy of Friedman Benda, New York,
and the Artist

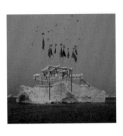

47. *Island*, 2010
 Chromogenic print
 40 x 40 inches
 Courtesy of Friedman Benda, New York,
 and the Artist

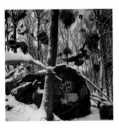

48. *Territorial*, 2010
 Chromogenic print
 40 x 40 inches
 Courtesy of Friedman Benda, New York,
 and the Artist

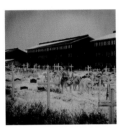

49. *Black House*, 2010
 Chromogenic print
 30 x 30 inches
 Courtesy of Friedman Benda, New York,
 and the Artist

Anthony Goicolea
Biography and Career Summary

Born in 1971 in Atlanta, Georgia, Anthony Goicolea is a first-generation Cuban American artist now living and working in Brooklyn, New York. His extended family immigrated to the United States in 1961, fleeing from Cuba soon after Castro came to power—a fact that underpins many of the artist's works. In his multi-faceted artwork, Goicolea explores themes ranging from personal history and identity, to cultural tradition and heritage, to alienation and displacement. His diverse oeuvre encompasses self-portraits, landscapes, and narrative tableaux executed in a variety of media, including black-and-white and color photography, sculpture and video installations, and multi-layered drawings on Mylar.

Best known for his powerful, and often unsettling, staged photographic and video works, Goicolea made his artistic debut in the late 1990s with a series of provocative multiple self-portrait images. These early works featured groups of young boys on the threshold of adolescence, acting out childhood fantasies and bizarre rituals of revelry and social taboo in highly staged domestic or institutional settings or dense, fairytale forests. Revealing a playful self-consciousness, they often consisted of complex composites of the artist himself, in all manner of poses and guises.

Soon thereafter, Goicolea garnered international attention with his ambiguous yet strangely compelling landscapes, ranging from dream-like woodland environments to vast, unforgiving urban and industrial wastelands. The artist has created several series of digitally composited, and heretofore uncharted, topographies, often populated by bands of masked and uniformed figures. In recent series, many of the images are devoid of humans, although the landscape reflects an anonymous and increasingly tenuous human presence. In these works, primitive lean-tos and crudely constructed shanties coexist in an uneasy union with the technological vestiges of an industrialized society. Suggesting a world on the brink of obsolescence, these chilling images further cement the pervasive undercurrent of human alienation—from one another as well as the natural environment—that can be traced throughout the artist's work.

In a marked departure, Goicolea trained his unflinching eye on his own personal history in a highly acclaimed body of work exploring his roots and family heritage. These poignant, sometimes cinematic, images and installations are characterized by a fervent search for ancestral and social connections to a mythical homeland, Cuba—at once revealing nostalgia for a past that the artist never actually experienced, as well as a pronounced sense of cultural dislocation and estrangement.

Remarkably prolific and inventive, Goicolea continues to intrigue his viewers with meticulously crafted, thought-provoking works. The artist has exhibited widely in group and solo exhibitions throughout the United States, Canada, Europe, and Asia—notably at the Museum of Contemporary Photography, Chicago, Illinois; the Corcoran Gallery of Art, Washington, D.C.; the International Center of Photography, New York; Postmasters Gallery, New York; Haunch of Venison Gallery, London, United Kingdom; Galerie Aurel Scheibler, Berlin, Germany; the Groninger Museum, the Netherlands; and the Museo Nacional Centro de Arte Reina Sofia, Madrid, Spain. *Alter Ego: A Decade of Work by Anthony Goicolea* is the first major museum exhibition devoted solely to his work. Goicolea's art is held in many public collections, including those of the Whitney Museum of American Art, the Solomon R. Guggenheim Museum, and the Museum of Modern Art, New York; as well as the Yale University Art Collection, New Haven, Connecticut; the North Carolina Museum of Art, Raleigh; and Telfair Museums, Savannah, Georgia.

To date, Goicolea's work has been the subject of three books. It has been featured in several anthologies as well as *ARTnews, Art in America,* the *New Yorker,* the *New York Times,* the *Los Angeles Times,* the *Advocate,* the *Chicago Sun-Times,* and the *Chicago Tribune,* among many other publications. The artist's recent grants and awards include a Cintas Fellowship (2006) and the BMW Photo Paris Award (2005).

Goicolea holds a B.A. in art history, with a minor in romance languages, and a B.F.A. in drawing and painting—both earned at the University of Georgia, Athens, in 1992 and 1994, respectively. He received an M.F.A. in sculpture, with a minor in photography, from Pratt Institute of Art, New York, in 1996.